<u>Shot</u> <u>By</u> <u>Shot</u>
A Practical Guide to Filmmaking

Third Edition

by
John Cantine • Susan Howard • Brady Lewis

PITTSBURGH
FILMMAKERS

THE MEDIA ARTS CENTER

Illustrations: Jennifer E. Merriman
(except p. 11, 100, 103, by Andrew Sproule)
Photographs: Richard D. Kelly
Design/Layout: Andrew Sproule
Cover Image: From *A Trip to the Moon* by Georges Melies
A Trip to the Moon and Muybridge motion study:
The Museum of Modern Art/Film Stills Archive

ISBN 0-9637433-2-5

Published by:
Pittsburgh Filmmakers
477 Melwood Avenue
Pittsburgh, PA 15213

Shot By Shot
A Practical Guide to Filmmaking

Third Edition

Table of Contents

Foreword by John Columbus <u>4</u>

Preface <u>7</u>

Introduction: The Moving Image <u>9</u>
Formats • Film Styles

1. Camera and Lens <u>16</u>
Camera Mechanics • Projected Motion • Lenses • Exposure • Light
Metering • Focus • Depth of Field Tables

2. Film Stock <u>42</u>
Negative and Reversal Film • Black-and-White and Color • Film
Sensitivity • Color Balance • 16mm Film Stocks • Super-8 Film Stocks

3. Composition <u>52</u>
Shots and Image Size • Camera Angles • Compositional Guidelines •
Composition Outside the Frame • Camera Movement • Movement in the Shot

4. Continuity <u>68</u>
Space and Time on Screen • Screen Direction • The 180-Degree Rule •
Changing Screen Direction • More About Continuity • Overlapping
Action and Master Shots

5. Film Editing <u>82</u>
Editing and Continuity • Alternatives to Continuity • Film Editing
Mechanics • Fades and Dissolves • Cleaning • Storage • Video Transfer

6. Digital Editing <u>98</u>
Input • Editing • Transitions and Graphics • Output

7. Pre-Production <u>108</u>
Writing the Film • Preparations • Final Planning

8. Lighting <u>121</u>
Light Measurement • Quality of Light • Lighting Tools • Lighting
Angles • Three-Point Lighting • Motivated Light • Color •
Lighting Contrast • Night Shooting • Shooting Titles

9. Sound <u>141</u>
Characteristics of Sound • The Sine Wave • Microphones • Pick-up
Patterns • Magnetic Tape Recorders • Single-System Sound •
Double-System Sound • Sound Editing and Mixing on Film • Digital
Audio Recording • Digital Sound Editing and Mixing

Glossary <u>156</u>

Index <u>180</u>

About the Authors <u>189</u>

About Pittsburgh Filmmakers <u>190</u>

Foreword

When a teenager, I hounded my parents for an 8mm movie camera. I suppose it was the prospect of moulding time that seduced me, an aspiration facilitated by the 8mm camera I found waiting under the tree that Christmas. Over the next few years I happily made a string of family chronicles but could not yet fully rationalize my addiction to amateur movie making. Later in art school our sculpture professor urged us to explore film directing because it offered new expressive opportunities and was probably the most influential art form of the century. That was when Fellini's *8 1/2* came to town. After college I joined a filmmakers' cooperative in Soho where Jack Smith produced and exhibited work but I modeled my aesthetics on the films of Deren, Warhol, Marker, Emshwiller, Antonioni, Leacock and Kubrick. These auteurs invoked dreamscapes, tapped into the subconscious, poetically and incisively chronicled the "real" world as well as the times and challenged the status quo.

In graduate school I discovered Flaherty, Vertov, Eisenstein, Frampton, Bresson, Ozu and others, all of whom demonstrated that film was essentially unlike any earlier medium. I now understood that it was the filmmaker's ability to manipulate visual, temporal and audio interactions, explore metaphor, surrealism, rhythm and scale while simultaneously speaking from the soul that so attracted me as a teenager.

Cinema is less than 125 years old and we have only begun to digest its expressive potential. We are still discovering the medium's plastic attributes and evolving its vocabulary. Today, exponents of visionary

film such as Scott McDonald are exploring the achievements of artists like Stan Brakhage, Peter Rose, Trin Minh-ha, Su Friedrich, Peter Hutton, Martin Arnold and Raphael Ortiz, while scholars Erik Barnouw, George Stoney, Stefan Sharf and Patti Zimmerman have introduced generations of film students to documentary film, narrative theory and the polemics of cinema.

Students whose imaginations are fertile will want to gain knowledge of the basic tools, techniques and precedents upon which informed exploration of the potential of this medium is based. Sometimes, even in the realm of a mature mechanical technology, someone manages to shed new light on the subject. Filmmaking can be a very intimidating enterprise, especially when the primary model in most peoples' minds is the large feature-style production team. For a few there is perhaps the rustic underground alternative but this also can be daunting. So what route might an aspiring novice filmmaker choose to gain entree to the medium, to understanding and not being intimated by the equipment, the techniques, digital post-production and the nomenclature? In my 24 years teaching film production I have sought a compact yet inclusive introductory manual for my students. I have wished for a well-organized text which demystifies the process and makes film technology and now the digital interface accessible. I've searched for a publication which covers all essential details concisely and which might also engage the student sufficiently to impel her or him to further study the tools, forms and innovators of the discipline.

Usually the production books I have encountered have been too campy and casual, or ponderous with technical jargon aimed chiefly at industry professionals. Filmmaking is a complex process, a rich one, involving many skills, including organizational ones, as well as common sense and aesthetic wisdom. This new edition of *Shot by Shot: A Practical Guide to Filmmaking* has been most capably updated and once again succinctly achieves a much appreciated balance thanks to the conscientious labor of the three authors, all of whom are variously recognized for their teaching, filmmaking

or technical expertise. I am again impressed with the directness, lucidity and pragmatism of this product. The authors' sensible strategy is to clearly present practical standards and examples based on 16mm filmmaking, but it also includes super-8mm filmmaking, and very importantly, computer editing for release printing on film. This strategy serves the reader well in this age of digital discipleship. This informative text instructs without being pedantic, and its authors' commitment to craftsmanship provides lessons which are relevant for years to come no matter what turns technology may take in the foreseeable future.

John Columbus

John Columbus is founder and director of the nationally prominent Thomas Edison, Black Maria Film and Video Festival and Adjunct Associate Professor teaching filmmaking at the Department of Media Arts, University of the Arts, Philadelphia. His short film Corona, *an independent memoir about growing up near the Jersey Shore, is near completion.*

Preface

We wrote the first edition of this book because, as teachers, we needed a book that would be appropriate for our beginning filmmaking students. In the second edition we expanded the text substantially, added many new photographs and improved the illustrations. In writing this third edition we have reconsidered and revised every chapter, updated information throughout and written major new sections on digital editing and digital audio. We have worked to maintain our original premise that this sort of introductory text should be, above all, clearly stated and easy to use, containing enough but not too much information and affordably priced for production students whose priorities tend to be film and processing.

Since we first published *Shot By Shot: A Practical Guide to Filmmaking*, we have discovered that it is used by students and in production programs using 16mm film, super-8 film and, sometimes, videotape as beginning format. This book grew out of the needs of the filmmaking curriculum at Pittsburgh Filmmakers, where we all teach. This text is designed for filmmakers, whether they are working in 16mm film or in super-8, and it is specific in regard to each format. It addresses the issues involved in digital post-production, and it does so with the idea that the finished work is intended to be shown on film rather than videotape. We have tried to be thorough in introducing and discussing important basic concepts of filmmaking, but it was never our intention to go into great technical detail in any specific area. There are other good books available that go into much greater detail, and we use some of them in our advanced classes. This book's goal is to provide a

new filmmaker with the right amount of information to get started, without overloading him or her with too many intimidating circles of confusion, characteristic curves, tape bias adjustments or SCSI I.D. numbers.

We have tried to introduce filmmaking concepts and language in a practical, understandable way. Each new film term is set in boldface and is defined within the body of the text the first time it appears. A concise definition of each boldfaced term can be found in the glossary. "Pre-production" is the seventh chapter in the book, and while an argument could be made for discussing it before anything else, it is impossible to outline the concepts of good pre-production without first having an understanding of the terms, details and potential pitfalls involved in shooting and editing.

We would like to thank our friends and colleagues who have helped us in this effort. Dean Mougianis researched, organized and wrote preliminary drafts of the new sections on digital editing and digital sound. Andrew Sproule did the layout for the third edition. Kathleen Rebel, Michael Bonello and Laura Jordan deserve thanks for their work in coordinating the book's distribution in recent years. Kate Knorr and Gary Kaboly of the 61C Cafe let us over-run their place to shoot the photographs in Chapters 4 and 5. Richard Kelly shot all the photographs. Gus Samios lent us his legal expertise. Karen Trischler created the index and Merging Media (formerly Electronic Images) assisted with the cover artwork. Charlie Humphrey provided advice, support and computer expertise. We thank all of them plus the entire staff of Pittsburgh Filmmakers for indulging us in this on-going project. Thanks to John Columbus for being an ardent supporter and thanks to all the other users of the first and second editions, including many of our own students, who gave us feedback and encouragement.

Brady Lewis • Susan Howard • John Cantine
October 2000

Introduction:
The Moving Image

At about the time inventors began to perfect the photographic process in the late nineteenth century, they also began to consider techniques by which they could photographically reproduce motion. Nineteenth-century parlor toys such as the zoetrope and flip books demonstrated that the human eye retains the impression of an image slightly longer than it is actually exposed to that image. When a series of drawings or photographs are viewed in rapid succession, the eye blends the individual pictures together. This is called **persistence of vision**. If there is a very small difference in position from one image to the next, the brain will perceive movement when the images are viewed in rapid succession. If, for instance, a person is in one position in one image and is slightly to the right of that position in the next, the viewer will perceive the person as being in motion and moving to the right. The difference from image to image must be very slight for this phenomenon to occur.

In the 1870's Eadweard Muybridge successfully demonstrated the photographic reproduction of motion when he set up a row of still cameras and photographed a racehorse running past them.

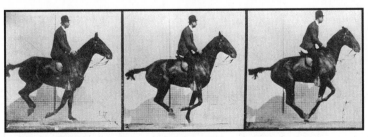

A motion sequence photographed by Eadweard Muybridge.

When viewed in rapid succession these images provided a graphic example of photographed motion. However, setting up a series of still cameras to capture a second or two of action was not a practical method of photographing motion, and inventors worked to develop a camera that would rapidly expose a series of sequential images onto a single strip of film.

A breakthrough in the development of the movie camera occurred with the invention of flexible celluloid film stock, which replaced the cumbersome glass plates previously used to capture light and create the photographic image. In 1888 George Eastman marketed the first celluloid film. The flexible strip of film had **sprocket holes**, or perforations, along its edges. Inside the camera the teeth of **sprocket wheels** engaged these perforations, moving the film through the camera. In 1890 William Dickson and Thomas Edison successfully tested a motion picture camera, and in 1895 the Lumiere brothers made the first public motion picture presentation.

Format

In filmmaking the term **format** refers to the gauge or width of the strip of film. The **35mm** format, the format used by Edison's first motion picture cameras, is still the standard today in feature and commercial filmmaking. 35mm film is 35 millimeters (about 1 1/2 inches) wide. Over the years other formats have been developed. In the 1920's the **16mm** format appeared as a less expensive alternative to 35mm. Originally aimed at home users, this format became useful to documentary filmmakers and newsreel photographers, because its smaller size meant a reduction in the size and weight of the motion picture camera used to expose it. The smaller camera improved the filmmaker's mobility and ability to shoot in confined spaces.

The **8mm** format came into existence in 1932. 8mm film was actually 16mm film with twice the number of sprocket holes. The 16mm film was run through an 8mm camera that exposed one

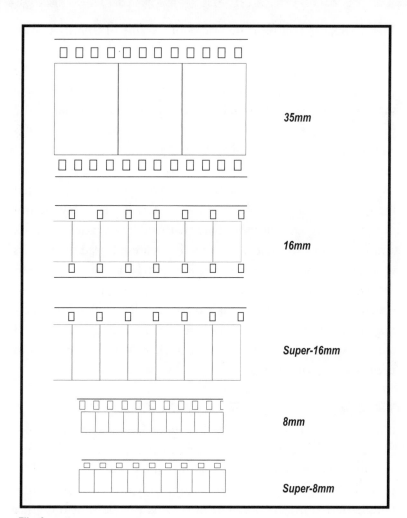

Film formats

edge of the film. It was rethreaded and run through the camera again, exposing the frames along the other edge. The processed film was then split down the middle lengthwise, resulting in two reels of 8mm film. In 1965 Eastman Kodak introduced **super-8mm** film. This format was the same width as regular 8mm, but the sprocket hole size was reduced and spacing was redesigned to provide a 50% larger frame, thereby greatly improving image quality.

The shape and relative dimensions of a frame of film in a given format are described by a simple numerical ratio of the frame's width to its height. This **aspect ratio** defines the shape of the rectangular frame. The motion picture frame is always a rectangle that is wider than it is high, but there can be some choice in the specific aspect ratio in some of the larger formats. Before 1953 almost all 35mm theatrical films had an aspect ratio of 1.33:1, meaning that the frame was one-and-one-third times wider than its height. This ratio can also be expressed as 4:3. If the projected image is four feet wide, it will be three feet high. Today, 35mm theatrical films are commonly shot with an aspect ratio of 1.85:1, a much wider rectangle, and some films are released to theaters with even wider aspect ratios, like 2.35:1. These wide-screen formats came about as the film industry sought new ways to attract audiences to theaters, a direct result of television's new popularity in the 1950s. 8mm, super-8mm and 16mm film all use the standard aspect ratio of 1.33:1 that was established in the early days of cinema.

The **super-16mm** format was introduced in the 1960's but was not widely used until the late 1980's. Super-16 uses standard 16mm film but the image is wider, resulting in an aspect ratio of 1.66:1. 16mm film is made with sprocket holes along both edges (**double-perf film**) or with sprocket holes along only one edge of the film (**single-perf film**). Standard 16mm films can be shot on either double-perf or single-perf film. Super-16 simply uses single-perf 16mm film in combination with a modified camera design that allows the wider image to fill most of the frame area on the film's other edge (where sprocket holes would exist on double-perf film). The film itself is not a different format from standard 16mm film.

Super-16mm is usually chosen when shooting a lower budget film that is intended for 35mm release. While the 16mm film and processing costs help keep the expenses down (when compared to 35mm), s-16 has an aspect ratio (1.66:1) that is much closer to the normal 35mm theatrical aspect ratio (1.85:1) than that of

standard 16mm (1.33:1). Consequently, super-16 film can be **blown-up** (photographically enlarged from one format to another) to 35mm and the 1.85:1 aspect ratio with less magnification, and therefore with higher image quality, than is possible in a standard 16mm to 35mm blow-up. However, films shot in the s-16 format cannot be shown in the s-16 format. Since the image extends almost to the edge of the film, there is no room for a soundtrack. Super-16 films must be blown-up to 35mm or transferred to videotape in order to be shown. Finally, it is worth noting that most European countries use a standard 35mm theatrical aspect ratio of 1.66:1, so s-16 can be blown-up perfectly for European release.

Film Styles

Films are frequently categorized within one of four general styles: **narrative, documentary, animation** or **experimental**. Many films actually combine elements of two or more of these groups but can be described broadly by one of these terms.

The narrative film is probably the most recognizable type of film. Almost every theatrically released motion picture falls into this group. Simply put, a narrative film tells a story. It is scripted and usually has a plot line with a beginning, middle and end, although the action may not unfold on screen in a linear fashion. The story may be presented in a simple straightforward way, as in John Ford's classic *Stagecoach* (1939), or in a very complex way, as in *Last Year at Marienbad* (1961). In the first example the story unfolds in a linear, chronological order; in the second the action jumps backward and forward in time, and the viewer is forced to mentally create a chronology of events. In any case the narrative film tells a story featuring characters whose actions advance the plot.

Documentaries are films that depict "real life." A documentary filmmaker uses the world around him, situations and people that actually exist, as source material. Among the very earliest

filmmakers, France's Lumiere brothers began making documentaries in the 1890's. Their films presented everyday occurrences such as a train pulling out of a station or workers leaving a factory at the end of the day. Over the decades filmmakers have documented events of global significance, such as wars and social upheavals, as well as smaller subjects such as ordinary individuals.

In its most basic sense a documentary is a film in which the filmmaker allows the action or events to unfold naturally with minimal interference. However, this definition breaks down the minute the filmmaker turns his camera from one subject to another or makes a cut. The very process involved in making a film requires that the artist manipulate the subject material to some extent. Differences in documentary style are often a matter of the degree of manipulation the filmmaker chooses to impose. Documentary films can range from works like Robert Flaherty's *Nanook of the North* (1922) and Errol Morris' *The Thin Blue Line* (1988), in which much of the action is actually staged, to the "cinema verite" of Frederick Wiseman who, in works like *Belfast Maine* (1999), manipulates his subjects in a subtler way through the editing structure he imposes on his footage. They can include lyrical, poetic films like the British documentary *Night Mail* (1936) and intimate personal histories like Chris Smith's *American Movie* (1999) and Werner Herzog's *Little Dieter Needs to Fly* (1998) as well as films dealing with historical events like Ken Burns' *Civil War* series (1990).

Animation is a type of filmmaking that creates the illusion of movement where none actually existed. Animators work with many different materials and with a wide variety of stylistic approaches. Drawings, objects, clay, puppets or other materials are manipulated in front of the camera. A single frame of film is exposed before replacing one piece of artwork with another that is slightly different or before moving the material or object into a slightly different position. Like a live action sequence, an animated sequence consists

of a series of still photographs that each represents a progression from the previous one. If the increments of change are small enough and regular enough, a convincing illusion of motion will result. Classic drawn animation like *Pinocchio* (1940), clay animation like *Chicken Run* (2000) and eclectic works like Dave Borthwick's 1994 feature, *The Secret Adventures of Tom Thumb*, which combines clay animation with object animation and "pixilated" human actors, are a few examples of the variety found in animation techniques and styles. Recently, technological breakthroughs in computer animation and digital output to film have made films like *Toy Story* (1995) and Disney's 2000 release, *Dinosaur*, possible.

Experimental filmmaking is the broadest and least easily defined category in terms of cinematic style. "Experimental" seems to be a catch-all term for any film that isn't a narrative or documentary. Often experimental films are not concerned with presenting a fictional story or documenting external reality. An experimental film might be more concerned with the graphic elements of the shots, with the play of light and shadow, color or movement. It might explore the technical limits of the filmmaking process itself: what happens when you edit together a series of single-frame shots or shoot a film that is one continuous shot? Others might be interested in presenting a vision of internal reality, images from the filmmaker's subconscious. Films that combine elements of narrative, documentary or animated filmmaking, films that blur the boundaries of the usual categories, are frequently classified as experimental films. In many cases these films reject traditional filmmaking techniques and values in favor of new, unusual approaches. Sometimes films that take an unconventional stylistic approach to narrative or documentary material are considered experimental. A few diverse examples of experimental films include Maya Deren's *Meshes of the Afternoon* (1943), Stan Brakhage's *Dog Star Man* (1964) and Su Friedrich's *Sink or Swim* (1990). Godfrey Reggio's feature-length *Koyaanisqatsi* (1983) and Jim Jarmusch's *Stranger than Paradise* (1984) are more widely known films that are usually considered experimental.

Chapter 1:
Camera and Lens

A movie is essentially a series of still images on a strip of film. The exposure of film in a movie camera is similar to that in still photography. In a motion picture camera the **shutter** opens and closes quickly, letting light hit the photosensitive material on the film to create a **latent image**. With the shutter closed the film is advanced; then the shutter opens again, exposing another frame. A movie camera captures the sequence of movement by exposing many separate frames each second.

Camera Mechanics

Movie film comes rolled on the **feed reel**. As the camera's sprocket wheels turn, the teeth (or **sprockets**) engage the sprocket holes (or **perforations**) in the film, pulling it through the **camera gate**, the area behind the lens where the film is exposed to light. The sprocket wheels turn at a smooth, constant rate. But if the film went through the camera gate in constant motion the camera would not expose separate frames. Instead, each frame would be a blur. The film must not be moving when the shutter is open. The camera employs an **intermittent movement**, a stop-and-start movement, rather than constant motion to move the film through the gate. Since the sprocket drive moves constantly and the film in the gate does not, there must be some slack in the film between the sprocket wheels and the camera gate or the film will rip. This slack is formed by **loops** of film above and below the camera gate.

The camera gate consists of two plates. The **aperture plate** in front of the film has a rectangular opening, or aperture, through which light passes to strike the film. The **pressure plate**, behind the film,

presses on the film so that it remains flat against the aperture plate. Without the pressure plate the image would not stay in focus. In the gate the **pull-down claw** reaches up, engages a perforation and moves the film down one frame. The claw then disengages, reaching up for the next perforation. While the claw is disengaged the film is motionless, as light enters through the camera aperture and exposes a frame of the film. The pull-down claw completes this cycle many times each second, causing the film's intermittent movement through the gate. Many 16mm and 35mm cameras also employ a **registration pin**. The registration pin moves into a sprocket hole and holds the film absolutely still while the frame is being exposed.

If light were to hit the film all the time, the intermittent movement would not be effective. When the film moved it would blur the still frame just exposed. Light must be blocked from hitting the

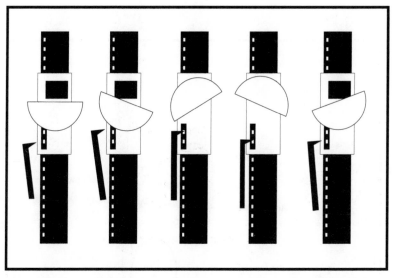

Intermittent movement. When the shutter is open the claw is disengaged and the film does not move. The claw moves up and engages a perforation. As the claw pulls the film down one frame, the shutter rotates so that it blocks the aperture and keeps light from hitting the film. As the shutter opening moves in front of the aperture, allowing light to hit the frame, the claw disengages and the film is again motionless.

film while it is moving in order to prevent this. In a motion picture camera the shutter is a flat disc of metal that spins in front of the aperture plate. It spins in synchronization with the pull-down claw. While the claw is pulling the film down, the shutter shields the aperture and no light hits the moving film. While the pull-down claw is disengaged and the film is still, the **shutter opening** is in front of the aperture and the light exposes the film. The shutter is usually described by the size of its opening. A **180-degree shutter**, for instance, is a semicircle of metal. 180 degrees of the circle are metal, and the other 180 degrees are open, the shutter opening.

The film path in a movie camera starts at the feed reel. The film is routed to a sprocket wheel, and it forms an upper loop between the sprocket wheel and the camera gate. After passing through the gate the film forms the lower loop. Then it is engaged by another sprocket wheel that carries it to the **take-up reel**, where the film is stored until it is developed. 16mm film is either packaged on a

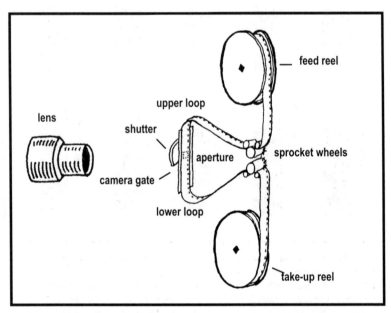

Diagram of a basic motion picture camera.

metal spool (100 feet of film wound onto a **daylight spool**), or it is wound in a 400-foot length on a plastic hub called a **core**. A daylight spool can be loaded into the camera in dim lighting. A core of film has no shielding and must be loaded in total darkness, either in a photographic darkroom or in a portable, light-tight **changing bag** or **changing tent**. In most cases 16mm film must be manually threaded through the camera. Super-8 film comes in a plastic cartridge, and everything behind the aperture plate (the reels, the sprocket drives, the loops, even the pressure plate) is inside the cartridge. The cartridge is popped into the camera in the same way that a cassette tape is loaded into a cassette recorder.

Projected Motion

When the exposed film is later shown, it runs through a projector in much the same way it ran through the camera. The main difference is that instead of light entering the camera to expose the film, a powerful lamp throws light through the film onto a screen. In the projector, as in the camera, a shutter spins and blocks light while the film is moving so that only still images are seen.

Film moves through a camera at a steady rate, the **frame rate** (also called the **camera speed**), which is measured in frames per second (**fps**). "Sound speed," the standard for 16mm and 35mm film, is 24fps. Silent super-8 cameras run at 18fps, while some super-8 sound cameras run at both 18fps and 24fps. Most of the time 18fps is used as the standard speed for super-8 film, but some filmmakers choose the 24fps standard when shooting super-8 sound film. Although super-8 sound film isn't being manufactured anymore, the option to shoot at 24fps is useful to filmmakers who shoot super-8 for transfer to video or with the intention of blowing it up to 16mm. The speed of the camera by itself does not matter as much as the relationship between the frame rate of the camera and that of the projector. For motion to look natural on the screen *the projector must run at the same rate as the camera*. If the camera runs faster than the projector, then the result is slow motion. For

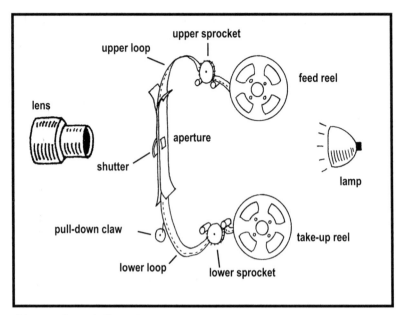

Diagram of a basic film projector.

instance, if the camera is run at 48fps, then an action that takes one second (e.g. lighting a match) will take up 48 frames of film. If the film is projected later at 24fps, those 48 frames will take two seconds to run through the projector. Everything will take twice as long as it did in real life.

Similarly, if the camera runs more slowly than the projector does (**undercranking**), **fast motion** will result. For instance, if the camera runs at 12fps, that one-second match lighting will cover 12 frames of film. When run through a projector at 24fps, those 12 frames will go by in half a second; everything will move twice as fast as it did in real life. In **time lapse** photography the frame rate might be one frame per second, one frame every 10 seconds or as slow as a frame every minute or even every hour. Very slow frame rates produce extreme compression of time so that clouds might seem to whip through the sky or a flower can bloom in a few seconds.

Animation is a type of filmmaking that doesn't actually have a frame rate. Rather than speeding up or slowing down natural motion, an animator creates motion by manipulating materials in front of the camera while shooting single frames of film. For example, a drawn animated sequence showing pink elephants dancing might consist of 360 drawings of the elephants in positions that are each slightly different from the previous one. If one frame of each drawing is photographed, then the sequence will be 20 seconds long when projected at 18fps. If the sequence is projected at 24fps, it will run for 15 seconds.

Lenses

Strictly speaking, the lens is not part of the camera. In fact, as the "pin-hole" camera demonstrates, a lens is not necessary to expose film. A pin-hole camera consists of a light-tight box with a tiny hole in one side that allows light to enter the box. Light entering through the pin hole exposes film on the opposite side of the box. However, it takes several seconds for this small amount of light to expose the film. The basic function of a lens is to gather light rays more efficiently and to focus them on the film so that it can be exposed more quickly. A camera lens consists of several pieces of glass, or **elements**, arranged inside a tube called the lens **barrel**. A lens is referred to by its **focal length**, which is determined by the arrangement of lens elements within the lens barrel. Focal length is an expression of the lens' size, usually stated in millimeters (mm). The focal length determines a lens' degree of image magnification. Lenses of different focal lengths will reproduce the same shot in different ways. A "normal" lens reproduces an image as closely as possible to the way the human eye sees it, with the least distortion of perspective. In the 16mm format a 25mm lens is considered normal. In super-8 a normal lens is one with a focal length between 12mm and 15mm. A 50mm lens is considered normal in the 35mm format.

A lens with a shorter focal length (under 25mm on a 16mm camera, less than 12mm in super-8) will gather light rays from a wider angle of view in front of it, and therefore it is called a **wide-angle lens.** Because of its short focal length a wide-angle lens can also be referred to as a **short lens.** These lenses tend to exaggerate the depth of a shot. An object will seem to be farther from the back wall than it is in reality. A woman walking toward the camera will appear to be moving faster than she is in reality, because her image will grow in size very quickly as she nears the camera. Wide-angle lenses can also cause horizontal lines to bend. The horizon line in a landscape, for instance, may curve slightly at either end of the frame. At very short focal lengths both of these effects are exaggerated, and the image becomes excessively curved and distorted. An extreme wide-angle lens that causes such effects is known as a **fisheye lens.**

A **long lens,** or **telephoto lens** (over 25mm on a 16mm camera, over 15mm in super-8), accepts light rays from a narrower angle of view in front of it. Small details of the scene will fill the frame. For instance, in three shots of a person from a fixed camera position, a wide-angle lens might show the person and some of the background. A normal lens might show the person from the waist up. A telephoto lens might show just the person's face. Since the telephoto lens seems to magnify small details of the scene, any unsteadiness of the camera will also be magnified so that a handheld or dolly shot using a long lens may be unacceptably shaky. If image steadiness is a concern, use a wide-angle lens. When using a telephoto lens, use a tripod. In addition, long lenses introduce some distortion. In contrast to wide-angle lenses which increase the perceived depth of a shot, telephoto lenses make the shot seem flatter. An actor in front of a wall will seem to be right up against it, even though he might be standing a considerable distance away from it.

This discussion has treated lenses as prime lenses. A **prime lens** has only one fixed focal length. A 10mm lens is only a 10mm lens, and a 75mm lens is only a 75mm lens. Prime lenses, or fixed focal

Three shots from the same distance and camera position with different lenses. Top, wide-angle lens; middle, normal lens; bottom, telephoto lens.

length lenses, are frequently used in 16mm and 35mm filmmaking. Most of the cameras used in these formats accept a variety of lenses, and lenses can be changed quickly and easily. It is common practice to use different prime lenses for different shots and situations.

Frequently, it is more convenient to use a **zoom lens**, a variable focal length lens, rather than prime lenses. Zoom lenses have a continuous range of focal lengths, from wide angle to telephoto. They are usually referred to by the range of focal lengths they cover. A "12-to-120 zoom" can be used as a 12mm wide-angle lens, a 120mm telephoto lens or at any focal length in between. With prime lenses, in order to change the composition from a long shot to a close-up, it is necessary to either move the camera or remove the lens and replace it with another. Using a zoom lens it is possible to zoom in to a telephoto shot or zoom out to a wide-angle shot by just turning a dial.

If you change focal lengths while the camera is running the result is a "zoom" shot. Before you use the zoom effect in a shot, as with any other camera movement, ask yourself why you want to do it. Is there a legitimate reason? Is the zoom appropriate or are you just bored? Zooms, like dollies, pans or tilts, should be designed to add or reveal important information within a shot. Zooming that is not motivated can be distracting and can look sloppy.

In 16mm and 35mm productions zoom lenses are typically used in conjunction with prime lenses. Prime lenses are rare in the super-8 format. Almost all super-8 cameras include a built-in zoom lens that cannot be removed. Some lenses used in the 16mm and 35mm formats, as well as the zoom lenses on many super-8 cameras, are **macro lenses**. Since many lenses cannot focus on anything closer than four feet away, a special lens is needed to shoot extreme close-up shots. A macro lens can focus on objects as near as several inches in front of the lens. While individual macro lenses used in 16mm and 35mm shooting simply allow the filmmaker to focus closer by turning the lens' focusing ring, super-8 cameras with built-in lenses may require the filmmaker to flip a switch on the camera

body or the lens in order to change the camera from its normal focusing range to the macro focusing range. If you want to fill the frame with a postage stamp or show a cricket on a stalk of grass, use a macro lens.

Exposure

In addition to gathering and focusing rays of light, lenses are used to control the amount of light reaching the film. When you enter a dark room on a sunny day, you can't see anything at first. Slowly your eyes adjust to the low light level and you can see details. The eye adapts to varying amounts of light by opening or closing its iris to let the right amount of light reach the retina.

A camera lens also has an **iris**, a metal diaphragm that can be opened or closed to control the amount of light reaching the film. If too much light hits the film, it will be **overexposed**. If too little light hits the film, it will be **underexposed**. The right amount of light is determined by the **speed** (sensitivity to light) of the film. A *fast* film needs less light than a *slow* film. (Film speed and the numerical rating systems that define it are discussed in detail in Chapter 2, Film Stock).

Whatever the speed of the film, it always needs a specific combination of exposure time and amount of light to be correctly exposed. The film's exposure time, or **shutter speed**, can only be controlled by changing the camera's **shutter angle** (simply another term for shutter opening) or by changing its running speed (fps). Most motion picture cameras don't provide the user with a way to change the shutter angle, and changing a camera's running speed to control exposure time is rarely an option, since a change in the frame rate also results in a change in the speed of motion on the screen.

As discussed earlier, the shutter of a motion picture camera rotates in front of the aperture plate, alternately letting light expose the film and then blocking light out. The shutter speed is the actual length of time

that the shutter lets light expose each frame of film. In order to increase the exposure time on the film, the shutter opening must be in front of the film for a longer period of time, and therefore the shutter must spin more slowly. Since the shutter of a motion picture camera is synchronized to the camera's intermittent drive, the only way to slow the shutter down is to slow down the camera's frame rate. For instance, at 12fps the shutter will let light hit the film twice as long as it would at 24fps. However, shooting at 12fps will result in fast motion. So, while manipulation of the shutter speed might be a viable means of controlling exposure for a still photographer who shoots one picture at a time, for the motion picture photographer changing the shutter speed is seldom a practical way to control the exposure of the film.

The amount of light hitting the film can be controlled in two ways: by actually changing the amount of light in the scene or by opening or closing the lens iris. If you are shooting outside on a sunny day, it's hard to change the amount of light in the scene. Often you'll have to use the available light (controlling light is discussed in detail in Chapter 8, Lighting). In most cases the best way to control the amount of light that hits the film is by opening or closing the iris in the lens. Just as the shutter speed determines *how long* light will hit each frame, the size of the iris opening will determine *how much* light hits the frame. (Note: the iris opening is also referred to as the lens **aperture**. Do not confuse this *adjustable* aperture in the lens with the fixed, rectangular camera aperture in the camera gate which is simply a frame-sized window cut into the aperture plate.) An **f-stop** is a number that indicates the size of the opening of the lens aperture (or iris). Every serious filmmaker should know the f-stop series:

1	1.4	2	2.8	4	5.6	8	11	16	22	32	45

← "opening up" "stopping down" →

As the f-stop numbers get higher, the size of the lens aperture opening is actually getting smaller, letting less light in. As the f-stop numbers get lower the aperture opening gets larger, letting more light in. Every time you **open up** one **stop** (from f/4 to f/2.8, for instance) you *double* the amount of light reaching the film. When you **stop down** one stop (from f/4 to f/5.6, for instance) you let *half* as much light in. If you change by more than one stop, every stop doubles or halves the light. For example, if you open up 3 stops (from f/4 to f/1.4, for instance), then you double the light 3 times to let in 2 x 2 x 2 = 8 times as much light. The list of f-stop numbers above is not exhaustive but a filmmaker will rarely, if ever, deal with lens openings larger than f/1 or smaller than f/45.

Light Metering

Working in 16mm a filmmaker will almost always use both a camera and a separate handheld light meter. The handheld meter can be a **reflected light meter**, an **incident light meter** or a combination of the two. Most super-8 cameras (and a few 16mm cameras) have a built-in light meter that controls the camera's lens iris when the camera is in its automatic mode. In effect these cameras combine two distinct instruments; a reflected light meter to measure light and a camera to take pictures. When the camera is in its automatic setting, the in-camera light meter reads the amount of light reflected by the subject, and then it automatically sets the lens iris to the indicated f-stop.

It is important to understand how reflected light meters work. Every reflected light meter is built and calibrated upon a **medium gray** standard. These meters are designed so that they give a light reading (an f-stop number) that is the correct exposure to use when you want the subject read by the meter to be reproduced on the film in tones that are equivalent to medium gray (also known as **18% gray** or **neutral gray**). Since

most shots include a variety of brightness, including light, dark and medium tones, the reflected light meter gives an average of what it sees. In many cases these light, dark and medium tones do, in fact, average out to something close to the medium gray standard, and exposure will be correct. The 18% gray standard was based on the assumption that most shots have a range of brightness that averages out to a shade of gray that reflects 18% of the light striking it.

In a so-called average scene, a scene which contains a range of brightness but is not dominated by very light or very dark objects, the light reflected by all the objects within the scene will average out to something close to 18% reflectance. In this case the light reading given by the reflected light meter will be correct. If you were to use the reflected light meter to take a reading from an object that reflects exactly 18% of the light striking it (for instance, an 18% **gray card**), the reading you would get would be the exact f-stop setting to use if you want the object to look medium gray on the film. However, if you were to take a light reading from a black object (a black cat, for example) or from a scene dominated by dark tones, the f-stop reading you would get would result in overexposure. Instead of looking black on the film, the black cat would appear to be medium gray. Everything else would be brighter too. Similarly, a reflected light meter reading of a white scene (a snow-covered hill with a bright sky behind it) would give an f-stop reading that would result in underexposure. The white hillside and sky would look medium gray rather than white on the film. Clearly, when taken at face value, reflected light meter readings are good for some situations and not for others. A reflected light meter always gives a reading that will reproduce *what the meter sees* as medium gray on the film.

Scenes dominated by extremes of brightness can result in light readings that, if taken at face value, will lead to severe overexposure or underexposure. This problem can be overcome if you simply use the standard (18% gray) to which the reflected light meter is calibrated. In the case of the black cat, you would take a light

reading from an 18% gray card (in the same light that is illuminating the cat) rather than taking a reading of the cat itself. In the case of the snowy hillside, you would read an 18% gray card, not the white hillside. As long as the gray card is read under the same light that illuminates the subject, these readings will result in an f-stop that would render a medium gray subject (the card) as medium gray on the film, instead of readings that would make black or white look medium gray on the film. If your exposure is based on a reading that will properly reproduce a medium gray object as medium gray on film, it should also reproduce brighter and darker tones properly.

When a super-8 camera is set to the automatic setting, the light meter built into the camera will take readings and simultaneously set the lens iris to the f-stop reading obtained. The automatic iris is *always* adjusting to the light. If the actor in a scene is walking down a dark hallway, the iris will open up to make it look brighter. If she walks past a bright window, the light meter will read the extra light and suddenly stop the lens down, and the actor will be underexposed. Overall, relying on the automatic iris can result in poorly exposed films. On most cameras the filmmaker can override the automatic iris and can set the iris to the correct f-stop, after taking a reading from a gray card. An automatic iris feature is extremely rare on 16mm cameras. In 16mm the f-stop must always be set manually using the f-stop ring on the lens.

To properly use an 18% gray card for reflected light readings, hold the card in the same light as the subject. The card must be angled to catch and reflect the light toward the camera position. The reflected light meter's field of view must be filled by the gray card. By taking a reflected light meter reading of an 18% gray card in this way and then manually adjusting the lens iris to the f-stop indicated, a filmmaker using a reflected light meter (whether it is built into a super-8 camera or it is a handheld meter that is being used in conjunction with a 16mm camera) can avoid most of the pitfalls of this kind of metering system.

Incident light meters are preferred in most situations by the majority of filmmakers. These meters measure the amount of light *falling on* the subject rather than the light reflected by the subject. Using an incident meter a black cat, a white rabbit and an 18% gray card under the same light will all give the same reading. Like reflected light meters, incident light meters are built and calibrated upon a medium gray standard. An incident light meter measures the light falling on the subject, and it tells the filmmaker how to expose the subject so that if it were an 18% gray object, it would be reproduced on the film looking like an 18% gray object. Objects that are lighter than medium gray will be reproduced lighter on the film and darker objects will be reproduced darker. In effect, an incident light meter is like a reflected light meter with a built-in gray card. A reflected meter used in conjunction with an 18% gray card will give the same readings an incident light meter gives.

While a reflected light meter's light-sensitive cell is pointed toward the subject (from the camera's position) in order to take a reading, an incident light meter is held at the subject's position and pointed toward the camera. An incident light meter's light-sensitive cell is usually covered by a translucent hemisphere (it looks like a small ping-pong ball, cut in half) that collects light from all side and front sources. This three-dimensional light collector actually simulates a three-dimensional gray card. The meter reading tells the filmmaker how to expose the film such that an 18% gray three-dimensional object would be accurately reproduced on the film.

Unlike a built-in reflected meter, an incident meter will only indicate the amount of light falling on the subject. The filmmaker must determine the proper f-stop based on the shutter speed of the camera and the sensitivity of the film. (Some incident light meters make the calculations internally, while others require the user to manually calculate the appropriate f-stop.) The reflected light meter built into a super-8 camera makes these calculations automatically and indicates an f-stop number.

left: Taking a reflected light meter reading without a gray card.
right: The resulting exposure.

left: Taking a reflected light meter reading using a gray card.
right: The resulting exposure.

left: Taking an incident light meter reading.
right: The resulting exposure.

Focus

The primary function of a lens is to gather light rays and focus them onto the film. By adjusting the glass elements in a lens, you can focus on objects at different distances from the camera; the numbers on the **focusing ring** of the lens indicate the distance the lens is focused on. If the focusing ring is set at ten feet, for instance, all objects on a plane ten feet away will appear to be **in focus**. The **plane of critical focus** is ten feet away. (Note: when measuring focus, one doesn't measure from the end of the lens, but from the **film plane** or **focal plane**, which is marked on the side of the camera by a ϕ symbol.) Objects in front of or behind the plane of critical focus will be **out of focus**; the farther they are from the plane of critical focus, the more out of focus they appear. Objects that are close to the plane of critical focus are so slightly out of focus that they *seem* to be in focus. Rather than just a flat plane being in focus, there is actually an area in front of and behind the plane of critical focus that appears to be in focus. This area, delineated by the near and far limits of acceptably sharp focus in a given situation, is known as the **depth of field**. Depth of field is not a constant. It can be a few inches, or it might be hundreds of feet. Depth of field depends upon three variables:

1. *Focal length*: Shorter (wide-angle) lenses provide greater depth of field than long (telephoto) lenses.

2. *F-stop*: Stopping down the iris increases depth of field; opening up decreases depth of field. Therefore, you will usually have less depth of field in low lighting, when the lens iris must be opened up.

3. *Focusing distance*: The farther the plane of critical focus, the greater the depth of field; the closer the camera is focused, the less the depth of field.

Two shots with the same image size. Depth of field is much greater when using a wide-angle lens (top) than when using a telephoto lens (bottom).

The final thing to keep in mind about depth of field is the "one-third two-thirds rule." That is, if there are two subjects at different distances from the camera that you want to have equally in focus, do not focus halfway between them. The depth of field extends farther behind the plane of critical focus than it does in front of it, so as a general rule, focus on a point one-third of the way beyond the nearer of the two subjects.

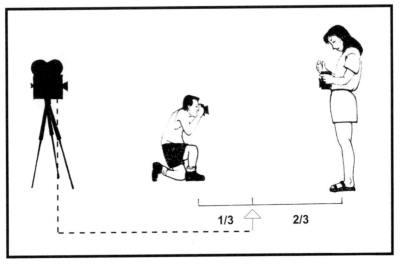

The one-third two-thirds rule. Focus is measured from the film plane in the movie camera to a point one-third of the distance beyond the nearer subject.

If the distance between camera and subject changes significantly during a shot, the filmmaker must **pull focus**, changing the focus while the camera is running in order to keep the subject in focus. Pulling focus may be required when either the camera or the subject is moving. If the movement is not very great and there is ample depth of field, it might not be necessary to pull focus.

The correct way to focus a zoom lens is to focus with the lens set at its longest focal length. Even if you are going to shoot a wide-angle shot of a person, zoom in on the person by turning the zoom ring on the lens to its extreme telephoto position. Adjust the focusing ring until this magnified image is sharp in the

viewfinder. Then zoom out and compose the wide-angle shot. Every shot should be focused by following this procedure. Zoom lenses should always be focused at their longest focal length, because you can see greater detail when the image is magnified. Further, when the lens is in its telephoto position, depth of field is minimized and focus is most critical. The focusing distance does not change when the focal length is changed. Focus is dependent upon the distance between the camera and the subject.

Depth of Field Tables

Depth of field tables are used to find the near and far limits of acceptably sharp focus. To obtain this information, use the tables for the format that you are using (16mm or super-8). Refer to the table for the focal length nearest the one you are shooting with. In that table find the column for the f-stop that you are using, and cross reference it with the appropriate corresponding row in the distance column (focusing distance). The numbers in the box where the column and the row intersect indicate the near and far limits of the depth of field for that specific combination of focal length, f-stop and focusing distance.

For example, in 16mm, shooting with a 25mm lens at f/2.8, focusing at 10 feet, the near limit is 8 feet 3 inches from the film plane; any object closer than that will appear out of focus. The far limit is 12 feet 7 inches from the film plane; any object farther away will appear out of focus. All objects between 8'3" and 12'7" will appear to be in focus. Keep in mind that depth of field falls off gradually. An object that is just outside the depth of field will be only slightly out of focus, while an object that is many feet beyond the depth of field will appear to be much more distinctly out of focus.

16 mm / Focal Length: 8mm

Distance	f/1.4 near far	f/2 near far	f/2.8 near far	f/4 near far	f/5.6 near far	f/8 near far	f/11 near far	f/16 near far
25'	7' ∞	5' ∞	4' ∞	3' ∞	2' ∞	2' ∞	1' ∞	1' ∞
15'	6' ∞	5' ∞	4' ∞	3' ∞	2' ∞	2' ∞	1' ∞	1' ∞
10'	5' ∞	4' ∞	3' ∞	3' ∞	2' ∞	2' ∞	1' ∞	1' ∞
8'	4'5" 43'	3'8" ∞	3'1" ∞	2'5" ∞	1'11" ∞	1'5" ∞	1' ∞	0'9" ∞
5'	3'4" 10'1"	2'11" 18'	2'6" ∞	2' ∞	1'7" ∞	1'3" ∞	1' ∞	0'8" ∞
3'	2'4" 4'4"	2'1" 5'4"	1'10" 7'8"	1'7" 23'	1'4" ∞	1' ∞	0'11" ∞	0'8" ∞
1'	0'11" 1'1"	0'11" 1'2"	0'10" 1'3"	0'9" 1'5"	0'9" 1'8"	0'8" 2'5"	0'7" 5'	0'6" ∞

16 mm / Focal Length: 10mm

Distance	f/1.4 near far	f/2 near far	f/2.8 near far	f/4 near far	f/5.6 near far	f/8 near far	f/11 near far	f/16 near far
50'	14' ∞	10' ∞	8'7" ∞	6'11" ∞	5'1" ∞	4'9" ∞	3'11" ∞	2'8" ∞
25'	10'1" ∞	5'2" ∞	3'11" ∞	2'11" ∞	2'2" ∞	1'7" ∞	1'2" ∞	0'10" ∞
15'	7'5" 84'	4'5" ∞	3'7" ∞	2'8" ∞	2' ∞	1'6" ∞	1'2" ∞	0'10" ∞
10'	6'4" 15'6"	3'11" ∞	3'2" ∞	2'6" ∞	1'11" ∞	1'5" ∞	1'1" ∞	0'9" ∞
5'	4'1" 6'8"	2'11" 8'2"	2'4" ∞	2'1" ∞	1'9" ∞	1'3" ∞	0'11" ∞	0'9" ∞
3'	2'5" 3'1"	2'1" 5'6"	1'10" 8'4"	1'7" 33'2"	1'4" ∞	1'1" ∞	0'10" ∞	0'8" ∞
2'	1'9" 2'5"	1'6" 2'10"	1'5" 3'6"	1'3" 5'0"	1'1" 12'7"	0'11" ∞	0'9" ∞	0'7" ∞

16 mm / Focal Length: 12mm

Distance	f/1.4 near far	f/2 near far	f/2.8 near far	f/4 near far	f/5.6 near far	f/8 near far	f/11 near far	f/16 near far
25'	12' ∞	10' ∞	8' ∞	6' ∞	5' ∞	3' ∞	3' ∞	2' ∞
15'	9' 46'	7'8" 465'	6'4" ∞	5'1" ∞	4' ∞	3' ∞	2' ∞	2' ∞
10'	6'11" 18'	6'1" 28'	5'3" 99'	4'5" ∞	3'7" ∞	2'10" ∞	2'2" ∞	1'8" ∞
5'	4' 6'5"	3'9" 7'4"	3'5" 9'1"	3' 13'11"	2'8" 573'	2'2" ∞	1'10" ∞	1'5" ∞
3'	2'8" 3'6"	2'6" 3'9"	2'5" 4'1"	2'2" 4'11"	1'11" 6'7"	1'8" 13'	1'5" ∞	1'2" ∞
2'	1'10" 2'3"	1'9" 2'4"	1'8" 2'5"	1'7" 2'9"	1'6" 3'2"	1'4" 4'2"	1'2" 6'11"	1' ∞
1'	1' 1'1"	0'11" 1'1"	0'11" 1'1"	0'11" 1'2"	0'10" 1'3"	0'10" 1'4"	0'9" 1'7"	0'8" 2'1"

16 mm / Focal Length: 16mm

Distance	f/1.4 near far	f/2 near far	f/2.8 near far	f/4 near far	f/5.6 near far	f/8 near far	f/11 near far	f/16 near far
25'	15'4" 69'	13' 270'	11' ∞	9' ∞	7' ∞	5' ∞	4' ∞	3' ∞
15'	10'10" 24'3"	9'9" 33'	8'6" 63'	7'2" ∞	5'11" ∞	5' ∞	4' ∞	3' ∞
10'	8' 13'5"	7'4" 15'8"	6'8" 20'	5'10" 36'	5' ∞	4'1" ∞	3'4" ∞	2'7" ∞
8'	6'8" 10'	6'2" 11'3"	5'8" 13'6"	5'1" 19'	4'5" 43'	3'8" ∞	3'1" ∞	2'5" ∞
6'	5'3" 7'1"	4'11" 7'8"	4'7" 8'8"	4'2" 10'7"	3'9" 15'4"	3'3" 46'	2'9" ∞	2'2" ∞
4'	3'8" 4'6"	3'6" 4'8"	3'4" 5"	3'1" 5'8"	2'10" 6'9"	2'6" 9'7"	2'3" 20'	1'10" ∞
2'	1'11" 2'1"	1'10" 2'2"	1'10" 2'3"	1'9" 2'4"	1'8" 2'6"	1'7" 2'10"	1'5" 3'4"	1'3" 4'9"

16 mm / Focal Length: 25mm

Distance	f/1.4 near far	f/2 near far	f/2.8 near far	f/4 near far	f/5.6 near far	f/8 near far	f/11 near far	f/16 near far
50'	33' 104'	29' 195'	25' ∞	20' ∞	16' ∞	13' ∞	10' ∞	7' ∞
25'	19'10" 33'9"	18'3" 40'	16'5" 52'	14' 98'	12' ∞	10' ∞	8' ∞	6' ∞
15'	13' 17'9"	12'3" 19'4"	11'5" 21'10"	10'5" 27'	9'3" 40'	7'11" 139'	6'9" ∞	5'5" ∞
10'	9'1" 11'2"	8'9" 11'9"	8'3" 12'7"	7'9" 14'3"	7'1" 17'2"	6'3" 25'	5'6" 55'	4'7" ∞
8'	7'5" 8'9"	7'2" 9'1"	6'10" 9'7"	6'6" 10'6"	6' 12'	5'5" 13'3"	4'10" 23'	4'1" 164'
5'	4'9" 5'3"	4'8" 5'4"	4'7" 5'7"	4'4" 5'10"	4'2" 6'4"	3'10" 7'1"	3'7" 8'5"	3'2" 12'4"
4'	3'10" 4'2"	3'10" 4'3"	3'9" 4'4"	3'7" 4'6"	3'5" 4'9"	3'3" 5'3"	3' 5'11"	2'9" 7'8"

16 mm / Focal Length: 50mm

Distance	f/1.4 near far	f/2 near far	f/2.8 near far	f/4 near far	f/5.6 near far	f/8 near far	f/11 near far	f/16 near far
25'	23'6" 26'9"	22'11" 27'7"	22'2" 28'9"	21'1" 30'8"	19'10" 33'9"	18'3" 40'	16'7" 51'	14' 97'
15'	14'7" 15'5"	14'3" 15'11"	13'11" 16'3"	13'6" 16'11"	13' 17'9"	12'3" 19'4"	11'6" 21'8"	10'5" 27'
10'	9'10" 10'2"	9'8" 10'5"	9'6" 10'7"	9'4" 10'10"	9'1" 11'2"	8'9" 11'9"	8'4" 12'7"	7'9" 14'3"
8'	7'10" 8'2"	7'9" 8'3"	7'8" 8'4"	7'7" 8'6"	7'5" 8'9"	7'2" 9'1"	6'11" 9'7"	6'6" 10'6"
6'	5'11" 6'1"	5'11" 6'2"	5'10" 6'2"	5'9" 6'4"	5'8" 6'5"	5'6" 6'7"	5'4" 6'10"	5'1" 7'4"
4'	4' 4'1"	3'11" 4'1"	3'11" 4'1"	3'11" 4'2"	3'10" 4'2"	3'9" 4'3"	3'9" 4'4"	3'7" 4'7"
2'	2' 2'	2' 2'	2' 2'	2' 2'	2' 2'1"	1'11" 2'1"	1'11" 2'1"	1'11" 2'2"

16 mm / Focal Length: 75mm

Distance	f/1.4 near far	f/2 near far	f/2.8 near far	f/4 near far	f/5.6 near far	f/8 near far	f/11 near far	f/16 near far
50'	45'7" 56'3"	44' 57'11"	42' 61'	39'3" 68'10"	36'2" 81'	32'4" 110'	28'7" 200'	23'11" ∞
25'	24'3" 25'9"	23'5" 26'10"	22'10" 27'8"	22' 28'11"	21' 30'11"	19'8" 34'4"	18'2" 39'11"	16'3" 54'7"
15'	14'7" 16'3"	14'5" 15'8"	14'2" 15'11"	13'10" 16'4"	13'6" 16'11"	12'11" 17'11"	12'3" 19'4"	11'4" 22'2"
10'	9'11" 10'2"	9'9" 10'3"	9'8" 10'5"	9'6" 10'7"	9'4" 10'10"	9' 11'2"	8'9" 11'9"	8'3" 12'9"
8'	7'11" 8'1"	7'10" 8'2"	7'9" 8'3"	7'8" 8'4"	7'7" 8'6"	7'4" 8'9"	7'2" 9'1"	6'10" 9'8"
7'	6'11" 7'1"	6'10" 7'2"	6'10" 7'2"	6'9" 7'3"	6'8" 7'5"	6'6" 7'7"	6'4" 7'10"	6'1" 8'3"
5'	4'11" 5'1"	4'11" 5'1"	4'11" 5'1"	4'10" 5'2"	4'10" 5'2"	4'9" 5'3"	4'8" 5'5"	4'6" 5'7"

16 mm / Focal Length: 100mm

Distance	f/1.4 near far	f/2 near far	f/2.8 near far	f/4 near far	f/5.6 near far	f/8 near far	f/11 near far	f/16 near far
100'	93'11" 106'11"	92' 110'	88' 115'	84' 123'	79' 135'	73' 159'	66' 204'	57' 389'
50'	48'5" 51'8"	47'9" 52'5"	47' 53'6"	45'9" 55'1"	44'3" 57'6"	42' 61'	40' 67'	36' 80'
25'	24'8" 25'5"	24'5" 25'7"	24'3" 25'10"	23'11" 26'3"	23'6" 26'9"	22'11" 27'7"	22'2" 28'8"	21'1" 30'8"
15'	14'11" 15'1"	14'10" 15'2"	14'9" 15'3"	14'7" 15'5"	14'6" 15'7"	14'3" 15'10"	13'11" 16'3"	13'6" 16'11"
10'	9'11" 10'1"	9'11" 10'1"	9'11" 10'1"	9'10" 10'2"	9'9" 10'3"	9'7" 10'4"	9'6" 10'6"	9'4" 10'9"
8'	8' 8'	7'11" 8'1"	7'11" 8'1"	7'11" 8'1"	7'10" 8'2"	7'9" 8'3"	7'9" 8'4"	7'7" 8'6"
6'	6' 6'	6' 6'	6' 6'	5'11" 6'1"	5'11" 6'1"	5'11" 6'1"	5'10" 6'2"	5'9" 6'3"

Super 8 / Focal length: 8mm

Distance	f/1.4 near far	f/2 near far	f/2.8 near far	f/4 near far	f/5.6 near far	f/8 near far	f/11 near far	f/16 near far
∞	7'10" ∞	5'7" ∞	4'1" ∞	3' ∞	2'3" ∞	1'8" ∞	1'3" ∞	1' ∞
35'	6'7" ∞	4'11" ∞	3'9" ∞	2'10" ∞	2'2" ∞	1'7" ∞	1'3" ∞	1' ∞
20'	5'10" ∞	4'6" ∞	3'6" ∞	2'8" ∞	2'1" ∞	1'7" ∞	1'3" ∞	1' ∞
10'	4'8" ∞	3'10" ∞	3'1" ∞	2'5" ∞	1'11" ∞	1'6" ∞	1'3" ∞	1' ∞
7'	3'11" 42'8"	3'4" ∞	2'10" ∞	2'3" ∞	1'10" ∞	1'8" ∞	1'2" ∞	0'11" ∞
5'	3'3" 11'4"	2'11" 26'7"	2'6" ∞	2'1" ∞	1'9" ∞	1'5" ∞	1'2" ∞	0'11" ∞
4'	2'10" 8'11"	2'7" 10'4"	2'3" 31'9"	1'11" ∞	1'8" ∞	1'4" ∞	1'2" ∞	0'11" ∞

Super 8 / Focal length: 12mm

Distance	f/1.4 near far	f/2 near far	f/2.8 near far	f/4 near far	f/5.6 near far	f/8 near far	f/11 near far	f/16 near far
∞	17'1" ∞	12' ∞	8'6" ∞	6'2" ∞	4'5" ∞	3'2" ∞	2'4" ∞	1'8" ∞
35'	11'8" ∞	9'2" ∞	7'1" ∞	5'4" ∞	4' ∞	3' ∞	2'3" ∞	1'8" ∞
20'	9'5" ∞	7'9" ∞	6'3" ∞	4'10" ∞	3'9" ∞	2'10" ∞	2'2" ∞	1'7" ∞
10'	6'6" 22'1"	5'8" 46'7"	4'10" ∞	4' ∞	3'3" ∞	2'7" ∞	2'1" ∞	1'7" ∞
7'	5'2" 11'1"	4'8" 14'10"	4'1" 27'3"	3'6" ∞	2'11" ∞	2'4" ∞	1'11" ∞	1'6" ∞
5'	4' 6'6"	3'9" 7'9"	3'4" 10'	3' 18'	2'7" ∞	2'2" ∞	1'9" ∞	1'5" ∞
4'	3'4" 4'11"	3'2" 5'6"	2'11" 6'6"	2'7" 6'11"	2'4" 17'11"	2' ∞	1'8" ∞	1'4" ∞

Super 8 / Focal length: 40mm

Distance	f/1.4 near far	f/2 near far	f/2.8 near far	f/4 near far	f/5.6 near far	f/8 near far	f/11 near far	f/16 near far
∞	240' ∞	210' ∞	150' ∞	105' ∞	75' ∞	52' ∞	38' ∞	26' ∞
50'	42'1" 62'9"	40'4" 65'9"	37'5" 75'3"	33'9" 96'	29'10" 152'	25'5" ∞	21'5" ∞	17' ∞
25'	22'9" 29'10"	21'7" 32'1"	20'11" 34'2"	19'8" 35'11"	18'1" 37'2"	17'5" 40'3"	15'10" 44'2"	14'9" 45'10"
10'	9'8" 10'5"	9'6" 10'6"	9'4" 10'9"	9'1" 11'1"	8'9" 11'7"	8'4" 12'6"	7'10" 13'9"	7'2" 16'6"
7'	6'10" 7'3"	6'9" 7'3"	6'8" 7'4"	6'6" 7'6"	6'4" 7'9"	6'2" 8'2"	5'10" 8'8"	5'5" 9'9"
5'	4'11" 5'1"	4'11" 5'2"	4'10" 5'2"	4'9" 5'3"	4'8" 5'5"	4'6" 5'7"	4'5" 5'10"	4'2" 6'3"
4'	3'11" 4'1"	3'11" 4'1"	3'11" 4'1"	3'10" 4'2"	3'9" 4'3"	3'8" 4'4"	3'7" 4'6"	3'5" 4'10"

Super 8 / Focal length: 60mm

Distance	f/1.4 near far	f/2 near far	f/2.8 near far	f/4 near far	f/5.6 near far	f/8 near far	f/11 near far	f/16 near far
∞	421' ∞	294' ∞	210' ∞	147' ∞	105' ∞	73' ∞	52'10" ∞	36'1" ∞
35'	32'4" 38'2"	31'3" 39'9"	30' 42'	28'3" 48'10"	26'2" 52'4"	23'7" 66'2"	21' 98'7"	17'8" 211'
20'	19'1" 21'	18'9" 21'8"	18'3" 22'1"	17'7" 23'2"	16'9" 24'8"	15'8" 27'5"	14'5" 31'9"	12'10" 43'
10'	9'9" 10'3"	9'8" 10'4"	9'6" 10'6"	9'4" 10'9"	9'1" 11'1"	8'9" 11'7"	8'4" 12'4"	7'9" 13'9"
7'	6'11" 7'2"	6'10" 7'2"	6'9" 7'3"	6'8" 7'4"	6'6" 7'6"	6'4" 7'9"	6'2" 8'1"	5'9" 8'9"
5'	4'11" 5'1"	4'11" 5'1"	4'10" 5'2"	4'10" 5'2"	4'9" 5'3"	4'8" 5'5"	4'6" 5'7"	4'4" 5'11"
4'	3'11" 4'1"	3'11" 4'1"	3'11" 4'1"	3'10" 4'2"	3'10" 4'2"	3'9" 4'3"	3'8" 4'5"	3'6" 4'7"

Chapter 2:
Film Stock

At its most basic level motion picture film is a strip of flexible material made of **cellulose triacetate**. This celluloid **base** is thinly coated on one side with a chemical **emulsion**. The emulsion consists of light sensitive **grains** of silver compounds suspended in a gelatin. When the emulsion is exposed to light, a chemical reaction occurs. The grains that are exposed to light change their chemical structure. Those which are not exposed remain unchanged. At this point no image is visible on the film; it contains a latent image. In fact, if you were to look at the film immediately after exposure, it would not only look unchanged, but you would ruin your film because the emulsion is still light sensitive. In order to render the film insensitive to light and to make the latent image visible, the film must be **processed** in a chemical developer.

When a film stock is manufactured, the cellulose triacetate base material is coated with an emulsion of light sensitive silver compounds called silver halides. During exposure and processing some of these silver halides are converted into grains of metallic silver. Where more exposure takes place, more metallic silver is formed.

Negative and Reversal Film

Film stocks can be described as either **negative** or **reversal** film. When shooting negative film, the emulsion that has been exposed to light is converted to metallic silver by the developer. The unexposed emulsion is washed away. Where a lot of light hit the film, a lot of metallic silver is left. Where no light hit the film, all

of the emulsion is washed off; the negative film is clear in these areas. If run through a projector, light would shine through these clear areas, making a bright area on the screen. Where higher concentrations of metallic silver are left, less light would shine through the film. If enough light has exposed an area of the film, it will be practically opaque in that area. So with negative film, objects that were bright create a dark image, and dark objects create bright images. Brightness values on the film are the opposite of the way they appeared in the camera's viewfinder; a negative image is obtained. A filmmaker using negative film does not project the **camera original** film, the film that ran through the camera. To restore tonalities to their proper values, a **positive print** must be made from the negative. It is this positive print that is handled and projected. This is similar to shooting still photographs and ordering prints. Strips of camera original negative are returned along with the prints, but it is the prints that you show to your friends. The negatives are only used to make additional prints.

THE NEGATIVE FILM PROCESS:

1. *Silver halide grains are exposed to light.*

2. *Exposed grains are converted to silver.*

3. *Unexposed emulsion is washed away.*

Reversal film is similar to slide film. When you project a slide, you are projecting the camera original film, yet the brightness and color values are the same as, not opposite, what you saw through the camera. This is due to the fact that when reversal film is processed, the emulsion that *has* reacted to light is bleached away. So where a lot of light has hit the film, a lot of emulsion becomes metallic silver and is bleached away, and the film is clear. Where no light has hit the film a thick layer of unexposed emulsion is left. In reversal processing that remaining emulsion is re-exposed to light in the laboratory and then developed again, so that it becomes metallic silver. What was bright in front of the camera is bright on the screen. What was dark appears dark on the screen. The brightness values remain the same as in real life. As a side effect, the emulsion that is left after developing is harder and more resistant to scratches than negative emulsion. It can therefore be run through a projector without being easily scratched.

THE REVERSAL FILM PROCESS:

1. Silver halide grains are exposed to light.

2. Exposed grains are converted to silver.

3. Silver grains are bleached away.

4. Remaining emulsion is re-exposed to light in the lab and developed a second time, resulting in a positive image.

16mm film is available in both negative and reversal stocks. When 16mm negative is used as the camera original, a positive print can be made from the negative. Normally, the negative film is processed at the film laboratory and a print, known as a **workprint**, is made from the negative. The workprint can be projected and edited. The negative camera original is stored and under most circumstances is never handled at all until the final stages of the editing process, when it is carefully cut to match the workprint and then used to make clean positive prints of the completed film. (For a more detailed discussion of the final stages of 16mm editing and printing, see Chapter 5, Film Editing.)

16mm reversal stocks are primarily intended (by the manufacturers) to be used in the same way as super-8 film. That is, the camera original is processed at the film laboratory and it is handled, projected and edited by the filmmaker. No print is involved. However, it is possible to make high quality prints from 16mm reversal camera originals. While some theatrical films, such as *Pi* (1998) and *Buffalo 66* (1998), have been shot on reversal film, the vast majority of professional filmmaking is done using negative film as the camera original.

With one exception, all super-8 films available from film manufacturers today are reversal films. Usually filmmakers who are working in the super-8 format handle and edit their camera original film rather than having a print made. It is possible to make a reversal film print from a reversal camera original, but it is very difficult to get good quality in a super-8 print. However, in recent years many negative films have become available to super-8 users. Eastman Kodak now offers one super-8 negative stock and a few independent companies have taken 35mm motion picture negative , cut it into 8mm widths, re-perforated it and packaged it in super-8 cartridges. Since there is no way to make a positive print from this super-8 negative, it must be transferred and finished on videotape. The results can be quite good, but the video transfer is expensive.

Black-and-White and Color

Another way to describe a film stock is by its color characteristics. With **black-and-white** (b&w) films only brightness values are reproduced. Black-and-white film stock does not react differently to different colors and does not reproduce color. If a red object reflects light as brightly as a green object, they will both appear as the same shade of gray on black-and-white film. The color film process involves the use of colored dyes. Color films react to and reproduce the colors of objects in the shot. While the image on a strip of black-and-white film consists of varying densities of metallic silver, a color film image consists of various intensities of three different colored dyes.

Film Sensitivity

Film stocks can also be described in terms of their sensitivity to light, or their **speed**. A **fast** film has grains that are larger and more sensitive to light. Less light is needed to cause them to react. **Slow** films have small, fine grains, and they require more light to achieve the same reaction. The speed of a film is expressed by an **EI** (Exposure Index) number. EI numbers are a way to compare the sensitivity to light of one film stock in relation to another. A film rated at EI 100 is twice as sensitive as a film rated at EI 50. It needs half as much light to achieve the same exposure. A film stock with a very high EI number is best to use under low lighting conditions. If there is plenty of light (outside on a sunny day, for instance) you might want to use a slower film, one with a lower EI number.

Note: EI numbers are the same as **ISO** (International Standards Organization) numbers and **ASA** (American Standards Association) numbers, and they can be used interchangeably with these other standards. They are *not* the same as **DIN** (Deutsche Industrie Norm) numbers, the European standard. While EI numbers have become the worldwide standard, people still commonly refer to ASA numbers as well, particularly in the United States.

A film is more sensitive to light if its light sensitive grains are larger. When a film is projected onto a large screen, these grains are easy to see, and they make the image lose some of its sharpness. That is one reason a filmmaker might want to use as slow a film as the light level will permit. Conventional thinking is that slow, fine grained film stocks produce sharper, more realistic and therefore more believable pictures. They don't distract the audience by drawing attention to the surface of the medium or to the photographic process. Of course, there might be times when you want to do just that, so the choice of a film stock can be an aesthetic option as well as a practical one.

Any film stock needs a certain amount of light to achieve the correct exposure. If too much light hits the film, it will be overexposed; if too little light hits it, the film will be underexposed. If the film is overexposed too much, the film will not be able to handle the light and will begin to burn out and lose detail. In a greatly overexposed shot of the sky, for instance, the sky will be completely white. The blue color and the clouds will be washed out by too much light. If the film is *underexposed* too much, then again details get lost. In a severely underexposed shot of a man standing in the shadows, the film will show only a black mass where the shadow is. The man will be lost in the underexposed area.

The amount of overexposure and underexposure a film stock can handle without losing detail is called the **latitude** of the film. Reversal film has very limited latitude. If you underexpose or overexpose by even one stop, you will begin to lose detail in the darkest or brightest areas. Negative film has much wider latitude than reversal film and can handle a greater range of brightness values.

Color Balance

Using color film introduces an important point to the filmmaker: all light is not the same color. If you are reading this book outside in the sunlight, you see the sunlight reflecting off the page as white light. If

you are inside reading by lamp light, you also see the light reflecting off the page as white light. This is because the eye and the brain, within certain boundaries, adjust to variations in the color of the light and see the dominant light as white (or neutral). In fact, daylight is much bluer than lamp light. You can see this easily when you are outside in the late afternoon and the lights have been turned on inside. The incandescent light shining through the windows of a house looks orange because your eyes are adjusted to the blue daylight. When you enter the house your eyes quickly adjust to the incandescent light and it appears white, without any color bias.

Although your eyes can adjust to variations in the color of light, film cannot. The color dyes in the light sensitive emulsion must be balanced during manufacturing to reproduce one, and only one, kind of light as white light. **Daylight-balanced** film reads daylight as white light. When using daylight-balanced film, uncorrected tungsten incandescent light will look orange. **Tungsten-balanced** film sees light from tungsten sources (such as movie lights or household light bulbs, but *not* fluorescent lights) as white light, and uncorrected daylight will look too blue. 16mm color film is available in both daylight-balanced and tungsten-balanced emulsions. When shooting daylight-balanced film under tungsten light, a blue **filter** (#80A filter) must be used to convert the orange tungsten light to the bluer color of daylight. When shooting tungsten-balanced film in daylight an orange filter (#85 filter) must be placed in front of the film. As the blue daylight passes through the filter, it is converted to the orange color of tungsten light.

Most super-8 cameras have a **filter switch** with two settings: ◯ (a light bulb) and ☼ (the sun). The filter switch controls the positioning of an orange #85 filter that is built into the super-8 camera. When shooting tungsten-balanced color film under tungsten lights, set the filter switch to the ◯ position, and the orange #85 filter is *out*. It does not affect the light. When shooting this type of film with daylight as the light source set the switch to the ☼ position

and the filter is *in*, converting the blue daylight to the orange color of tungsten light. In other words, wherever the light is coming from, the sun or a light bulb, set the filter switch to the corresponding position. (*Note*: On tungsten-balanced film fluorescent light appears greenish, and putting the filter *in* is usually better.)

When the filter is in it absorbs some of the light passing through it so that less light reaches the film. For this reason, when shooting black-and-white film, keep the filter out (the ⬯ position). Since black-and-white film does not react significantly to color variations anyway, there is no need for the filter and leaving it out allows the maximum amount of light to reach the film.

16mm cameras do not have filter switches. The light is filtered by mounting a glass filter in front of the lens. Some 16mm cameras allow the filmmaker to insert a small gelatin filter behind the lens. In either case, the filter will absorb some of the light passing through it. An orange #85 filter, for instance, absorbs about 2/3 of a stop of light. To compensate for the lost light, tungsten-balanced films are rated as slower films (needing more light) when used in daylight with a #85 filter. The lower EI rating they are assigned simply factors in the light absorbed by the filter. (For a more detailed discussion of color, see Chapter 8, Lighting.)

Black-and-white films have a nominally lower EI rating under tungsten light than they have under daylight. This is because black-and-white films are slightly more sensitive to blue light than to other parts of the spectrum, and daylight contains an abundance of blue light. No filtration is necessary when shooting black-and-white film, regardless of the type of light illuminating the subject. When a filter is used the EI rating for color films is lower to compensate for the light that is absorbed by the filter.

16 mm Film Stocks

As of October 2000 these are the individual 16mm film stocks that are available from Eastman Kodak:

Black-and-white Reversal:

7276 Plus-X	EI 50 (in daylight)
7278 Tri-X	EI 200 (in daylight)

Color Reversal:

7239 Ektachrome VNF	EI 160 Dayight
7251 Ektachrome VNF	EI 400 Daylight
7240 Ektachrome VNF	EI 125 Tungsten/80 Daylight w/85 filter
7250 Ektachrome VNF	EI 400 Tungsten/250 Daylight w/85 filter
7267 Kodachrome 25*	EI 25 Daylight
7270 Kodachrome 40*	EI 40 Tungsten/25 w/85 filter

(no latent edge numbers)

Black-and-white Negative:

7231 Plus-X	EI 80 (in daylight)
7222 Double-X	EI 250 (in daylight)

Color Negative:

7245 EXR 50D	EI 50 Daylight
7246 Vision 250D	EI 250 Daylight
7248 EXR 100T	EI 100 Tungsten/64 Daylight w/85 filter
7293 EXR 200T	EI 200 Tungsten/125 Daylight w/85 filter
7274 Vision 200T	EI 200 Tungsten/125 Daylight w/85 filter
7279 Vision 500T	EI 500 Tungsten/320 Daylight w/85 filter
7277 Vision 320T	EI 320 Tungsten/200 Daylight w/85 filter
7289 Vision 800T	EI 800 Tungsten/500 Daylight w/85 filter
7298 EXR 500T**	EI 500 Tungsten/320 Daylight w/85 filter

**(special order only)*

16mm film is available in a variety of lengths. A 100-foot roll of 16mm film has a running time of two minutes and 47 seconds at 24fps. A 400-foot roll will run for eleven minutes and eight seconds at 24fps. There are 40 frames in one foot of 16mm film.

Super-8 Film Stocks

As of October 2000 these are the individual super-8 film stocks that are available from Eastman Kodak:

Black-and-white Reversal:

7276 Plus-X	*EI 50 Daylight/40 Tungsten*
7278 Tri-X	*EI 200 Daylight/160 Tungsten*

Color Reversal:

Kodachrome 40	*EI 40 Tungsten/25 w/filter*
*7240 Ektachrome****	*EI 125 Tungsten/80 w/filter*

****note: If you are exposing 7240 Ektachrome using a super-8 camera's built-in metering system, you should open the lens by 1/2 stop from a reflected reading taken off a gray card. A super-8 camera's automatic metering system will read the notches on this film's cartridge as if it is an EI 160 film. If you don't open the lens iris, the film will be 1/2 stop underexposed.*

Color Negative:

7274 Vision 200T	*EI 200 Tungsten/125 Daylight w/filter*

All super-8 films are packaged in light-tight plastic cartridges containing 50 feet of film. The running time of a cartridge is three minutes and 20 seconds at 18fps (or two minutes and 30 seconds at 24fps). There are 72 frames in one foot of super-8 film, so at 18fps it takes four seconds for one foot to move through the camera.

Chapter 3:
Composition

The **frame** is the basic unit of visual material from which films are constructed. A continuous series of individually exposed frames constitutes a **shot**. Each time the camera is turned on, a new shot is exposed. When the camera is turned off, or when the film is cut and another piece of film is spliced in, the shot is over. Shots are edited together to build **scenes**. Any group of shots that is meant to be interpreted as being continuous in time and space constitutes a scene. A jump in space (e.g. from a character's bedroom to the street outside) or time (from the bedroom today to the same bedroom six months later) is usually interpreted as a change of scene. When shooting a film each shot is also referred to as a **camera take** or simply a **take**. A take can be described as the strip of film that is exposed from camera start to camera stop.

Shots and Image Size

Shots are most often defined by the size of the subject within the frame. There are three basic types of shots. They are usually abbreviated in scripts and storyboards as follows:

CU:	*Close-Up*
MS:	*Medium Shot*
LS:	*Long Shot*

When shooting footage of a person the close-up shot usually includes the person's head and shoulders. A medium shot might include the individual from head to waist. A long shot would show the entire

Extreme Long Shot (ELS)

Long Shot (LS)

Medium Shot (MS)

Close-Up (CU)

Extreme Close-Up (ECU)

person and a lot of the background. These are general guidelines. The different types of shots are *relative* to each other, and there are no strict rules.

Of course, films are not constructed from only these three types of shots. A film made up of too many similar shots can be visually uninteresting. Most films contain a variety of shots and image sizes, ranging from extreme long shot to extreme close-up. There are many shot variations within the three basic types. The most commonly used shots are described as follows:

ECU: Extreme Close-Up. *If shooting a person's face an ECU might only reveal the person's eyes.*

MCU: Medium Close-Up. *This falls somewhere between medium shot and close-up.*

MLS: Medium Long Shot. *This falls somewhere between medium shot and long shot.*

ELS: Extreme Long Shot. *This would show the entire person within the environment. The person would be a very small part of the frame.*

Camera Angles

In addition to image size, camera angle must also be considered when setting up a shot. Shooting with the camera placed at an appropriate vertical angle to the subject is important in giving emphasis to the content of a shot. For instance, if the camera is placed at an angle above the subject (a **high angle shot**) the subject appears to be physically diminished. The action or object often takes on a sense of insignificance or vulnerability. The effect when photographing from a low angle is just the opposite. In a **low angle shot** the subject seems to have added importance or power and appears dominant in the frame.

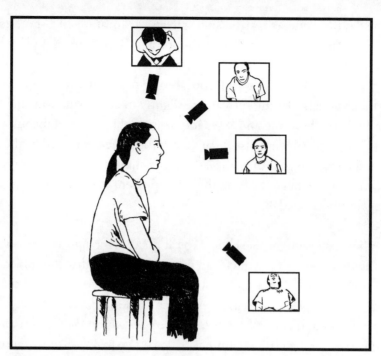

Vertical camera angles

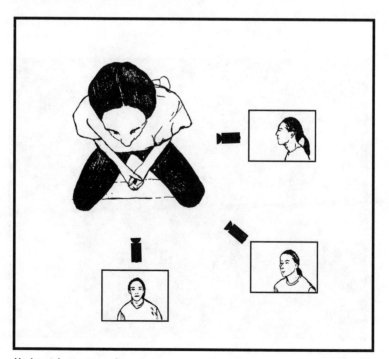

Horizontal camera angles

Just as the camera's vertical angle affects the meaning of a shot, its horizontal placement is equally important. If the camera is placed squarely in front of the subject, shooting straight on, depth is minimized. The subject will appear to be relatively flat, less three-dimensional. Moving the camera slightly to either side will allow a view of the front and one side of the subject simultaneously, adding apparent depth to the subject. If the camera is moved further to the side, so that only the side of the subject is visible and the front can no longer be seen, then the apparent depth of the shot is again diminished.

A filmmaker might also choose to tilt the camera slightly, creating a **Dutch angle** shot, which can create the feeling that the subject is unbalanced. Often evil characters or characters in dangerous circumstances are presented in Dutch angle shots, or such shots can be used to convey the instability of a situation. In his film *Do the Right Thing* (1989) filmmaker Spike Lee makes extensive use of Dutch angles as he portrays a neighborhood on the verge of violent collapse.

Dutch angle

Compositional Guidelines

Cinematic composition, the arrangement of objects and light within the frame, is similar to composition in photographs or paintings. However, pictorial composition for film must also take movement into consideration. Objects within the frame are often in motion, the camera itself is sometimes moving, or the focal length of the lens is being manipulated to alter the framing during a shot, creating dynamic, changing compositions. In addition, one shot is joined to another shot, creating a continuous sequence of compositions in flux.

Filmmakers recognize that effective composition evolves out of an intuitive sense of balance and harmony. This intuition is grounded in everyday experience in relating to the physical world. The filmmaker arranges objects within the rectangular space of the frame. When viewing such a specific space, our attention is naturally drawn to the most active points of that space. In the case of a rectangular space our view is drawn toward the corners of the frame where the vertical and horizontal lines meet. These are the most active or visually interesting points in the space. Objects that are centered in the frame tend to seem static, because this kind of framing does not draw attention to the active points within the frame. A centered composition can create a sense of stability, but it is also viewed less actively, since the eyes of the viewer do not tend to move through the frame. Most of the time filmmakers are concerned with keeping the audience visually engaged by encouraging their eyes to scan the frame. A compositional guideline that exploits the tendency to scan to the corners of the frame is the **Rule of Thirds**.

The idea of the Rule of Thirds is to divide the frame horizontally and vertically into thirds. In effect another frame is created within the frame, reinforcing the natural tension of the corners. By placing objects of key interest (a person's face, for example) at one of the

four points where the horizontal and vertical lines intersect, a filmmaker can draw the viewer's line of sight to the most significant elements within the shot.

Rule of Thirds

Another idea to consider when composing shots is the notion of compositional dominance. Often certain elements within a composition seem to take visual precedence. The viewer naturally tends to seek out the most dominant or primary element in a composition, then moves on to scan secondary elements. In a narrative film some elements within a frame take on dominance simply because of the dramatic or narrative context of the shot. The human face almost always functions as a dominant element. Faces often express emotion, providing crucial information within a shot.

Color can serve as a dominant element. In his film *Interiors* (1978), Woody Allen designed and photographed the entire film in muted earthy tones of brown and green. This was done to reflect the personalities of the central family who are a dreary bunch of repressed, soul-searching intellectuals. Suddenly, a new character is introduced into this group, the father's flamboyant, life-loving girlfriend. She is a *dramatic* dominant because of her clashing

personality. Allen costumed her in bright primary red, *visually* reinforcing her as a dominant element in contrast to the otherwise conservative color scheme of the shots.

The contrast between light and dark areas can also create compositional dominance. A very effective way to create an area of dominance within a composition is to increase the light in that area or on the subject. In Alfred Hitchcock's 1941 film, *Suspicion*, a man's wife suspects that he is trying to poison her. In a famous scene Hitchcock shows the man ascending a staircase carrying a glass of milk on a tray. Although the glass is the smallest object in the long shot, it becomes a dominant element because the glass itself is brighter than any other object in the frame. Hitchcock placed a small light bulb inside the glass, causing the milk to glow menacingly as the man approaches his sick wife's room. On the other hand, areas of darkness or shadow patterns within a shot can also serve as dominant compositional elements. Bernardo Bertolucci's 1969 film, *The Conformist*, includes a stunning scene in which a woman in a black-and-white striped dress dances in a room dramatically striped with light and shadow created by the room's Venetian blinds. The interplay between the stripes of the dress and the striped shadow pattern create a complex composition in which the woman is dominant as she moves through the frame, and a dynamic, changing pattern of light and dark lines moves over her.

Movement is one of the most powerful ways to call attention to an object or person. Moving objects attract the human eye. If one thing is moving in an otherwise static composition, it will usually become the single most dominant element of the shot. The opposite of this is also true. A stationary person surrounded by the hectic movement of a crowd will stand out as well.

Objects in the foreground of a shot, particularly a low angle shot, appear larger and therefore dominate the compositional scheme. However, filmmakers often place objects in the foreground of a shot even if they have no meaning in the dramatic context of the shot. The filmmaker might simply want to break up the foreground to lend a sense of

depth to the shot or to make the frame more graphically interesting. Sharpness of focus can also affect compositional dominance. An area of the frame that is in sharper focus than the rest of the frame will naturally attract the viewer's attention.

Composition Outside the Frame

Shots are often composed solely within the boundaries of the frame, with objects and action arranged in a way that takes into account only the rectangular space of the frame. However, it is frequently useful and even necessary to compose shots that make active use of the imaginary space that extends beyond the borders of the frame. Filmmakers often compose shots in which a portion of an important object appears at the edge of the frame. Since the rest of the object continues outside the boundaries of the frame, the audience is given a sense of the space that they do not actually see. People or objects moving into and out of the frame can also give the impression that space continues beyond the edges of the frame. The audience is encouraged, sometimes quite effectively, to imagine a much larger and more complex space than that which is defined by the edges of the screen.

A composition using off-screen space.

Camera Movement

Of course, the filmmaker has the additional consideration of movement when creating a shot. This might be the movement of an actor or an object through the frame while the camera is stationary, or it could be the motion created when the camera moves about a stationary object. Often both camera and subject are in motion.

If you are shooting a home movie it might be all right to carry the camera in your hand, waving it around to capture the action. Most home movies are shot **handheld**, but handheld shots are frequently shaky. A film with many unmotivated handheld shots can look amateurish, like a home movie. When shooting a landscape, a building or anything that doesn't move, the shot should be as steady as possible. To keep the camera steady it can be mounted on a **tripod**, a three-legged support. Unless there is a reason for a handheld effect, it is always a good idea to use a tripod to steady the camera.

Just as a tripod allows you to take the steadiest possible **static shot**, a good tripod also enables you to move the camera smoothly. In order to **pan** (short for panorama shot), pivot the camera along its horizontal axis so that the frame moves to the left or the right. You can pan along the horizon to show a landscape, or pan along a car from front bumper to back bumper. You can also pan to follow the subject's movement; if an actor walks to the right to open a door, you can pan right, keeping her in frame as she moves to the door. A **tilt** is a movement in which the camera pivots along its vertical axis. You can tilt up from the base of a skyscraper to the top, or you can tilt down from an actor's face to her feet.

When executing a pan or tilt set yourself so that your body is in a comfortable, balanced position at the *end* of the pan or tilt, and then twist back into the beginning camera position. This way your body can slowly, steadily unwind through the

camera movement. If you start out straight and twist into the pan or tilt, it will be harder to make the movement smooth because you will be moving into an unbalanced position.

In some situations you cannot or might choose not to use a tripod. If you were shooting footage of the running of the bulls in Pamplona, it would be difficult to move the tripod from one position to another fast enough to keep up with the action. In these situations a handheld camera is necessary. Handheld camera work is also an aesthetic choice that can add dynamism to a shot or scene. A handheld camera can be very effective when it is motivated by the demands of the film. *The Blair Witch Project* (1999) uses a handheld camera to make the film seem like home video shot by one of the characters. In Lars Von Triers' film *Breaking the Waves* (1996) handheld camera work is used to create a sense of chaos and emotional immediacy.

There are ways to make handheld shots steadier, with less distracting shakiness. As with any type of camera movement, it is necessary to rehearse handheld shots. When walking with the camera, keep your knees slightly bent so that they act as shock absorbers. Use short, even strides rather than long, bouncing ones. Keep your shoulders level; don't bounce up and down. You might look like Groucho Marx but the camera will move more smoothly and steadily. Of course, handheld shots taken with a telephoto lens will often appear shaky, because long lenses magnify the image and any unsteadiness of the frame will be emphasized. Consequently, wide-angle lenses usually work best for smooth handheld work.

If you put the camera on wheels (a wheeled platform, a wheelchair, a car) you have a **dolly** which can be used to move the camera in many ways. You can dolly in toward the subject; when Scotty, on the bridge of the Enterprise, realizes that the ship is doomed, the camera dollies in to get a close-up of his reaction. You can also start with a close-up and dolly out to reveal more of the setting.

A comparison of a zoom in (left column) and a dolly in (right column). The perspective changes are very different in each sequence.

You can dolly left or right to follow someone or you can dolly past a group of people waiting in line, from the front to the back of the line. A dolly shot, because it moves the camera through space, can be very dynamic and effective. However, if the dolly movement is shaky or uneven, the shot can look distracting and unprofessional. In that case a steady static shot might have been a better choice.

A **tracking shot** is a specific type of dolly shot in which the camera moves along with the subject. The camera might track left or right to follow a moving person, or it might track forward or backward, trailing or preceding a subject in motion. While the subject moves, the camera tracks with it, keeping it properly framed.

Even though a dolly in might seem to resemble a zoom in, it is actually very different. As the camera dollies toward a subject it moves through space. Perspective is constantly changing since the camera is constantly changing its position in relation to the objects in the frame. When the camera zooms in on a subject, the image is simply magnified. Objects in the foreground and the background are magnified equally. Perspective does not change since the camera stays in one position.

Movement in the Shot

In addition to camera movement a filmmaker must also consider the movement of actors or objects through the frame. Choreographing this movement as well as any movement of the camera during a shot is referred to as **blocking**. In some cases blocking can be elaborate and considerations of framing and camera angle are important. Understanding the compositional space within the frame makes it easier to block movement to create the desired meaning or feeling for a shot. Because the corners of the frame tend to draw the viewer's attention, movement through the frame on a diagonal is more dynamic than movement on a vertical or horizontal line. In chase scenes and action sequences filmmakers often make use of diagonal movement through the frame from corner to corner, to increase the feeling of movement. In contrast, consider a scene in which a group of people

are lost in a desert. A filmmaker might depict the group moving through the shot on a horizontal line. This type of composition does not exploit the inherent visual tension within the frame and effectively emphasizes the expanse of the environment and the unbearable slowness of the group's progress. David O. Russell uses such shots effectively in his 1998 Gulf War film, *Three Kings*.

Another important compositional consideration when shooting a subject in motion is the concept of **leading the action**. When the camera follows a person walking down the street, it is important to allow space between the person in motion and the edge of the frame. Unless there is more space in front of the character than behind him, he will seem to be running into the boundary of the frame and the shot will feel confined. Leading the action helps give viewers a sense of the space outside the frame, the space the subject is moving into.

In this awkward composition, the character seems to be running into the edge of the frame.

When the camera leads the action, the audience has a sense of the space the character is moving into. The composition seems more balanced.

Head room should be considered when composing shots. Similar to the concept of leading the action, some space should be allowed above and below a person's head when composing a close-up. If the top of the head or the chin is too close to the frame line, the shot will seem confined because the frame is emphasized and the composition will seem unbalanced. When shooting an extreme close-up, "cutting off" a little bit of the top of the subject's head can result in a strong composition that conveys a sense of the space outside the frame. In the same way, when shooting close-ups of a subject looking screen right or screen left, space should exist between the person's face and the edge of the frame. The idea of allowing proper head room, not too little space but not too much either, applies to medium shots and long shots as well.

Too much head room

Proper head room

Not enough head room

The filmmaker might also choose to change focus during a shot in order to direct the viewer's attention. A shot of a person waiting for a telephone call could start with the phone in the foreground of the frame but out of focus, making it seem unimportant. When the phone rings, the filmmaker can **rack focus** so that the telephone comes into sharp focus and the background goes out of focus. For a rack focus to be most effective the depth of field must be very shallow, so there will be a distinct shift when the focus is changed. Shooting techniques like these work best when they are well rehearsed before shooting. Often the camera operator will need an assistant who has the responsibility of manipulating the lens' focusing ring during the shot.

Compositional conventions are concerned with a sense of balance within the frame. The viewer intuitively attempts to harmonize the different elements within a composition into a cohesive picture. A filmmaker should use knowledge and understanding of compositional elements to create this balance, or if the scene so requires, to create a composition that is unbalanced. There are no hard and fast rules when it comes to creating effective compositions. Ultimately, the most successful compositions deal with the graphic needs of a shot (or scene) while simultaneously addressing considerations of meaning and content (narrative or otherwise). The best way to develop a good sense of composition is to study it on the screen.

Chapter 4:
Continuity

In most narrative films the filmmaker is attempting to create an on-screen reality by shooting actors, objects and places with specific spatial and temporal relationships. Later, the pieces of photographed reality (shots) can be edited together to produce an apparently seamless recreation of space and time that can seem almost as if the viewer is actually there experiencing it. This space and time continuum is a cinematic illusion created by careful shooting and editing. Maintaining these spatial and temporal relationships is called preserving the **continuity**.

Space and Time on Screen

Film is at once realistic and deceiving when it is used to represent or recreate the world around us. Films are usually created with images of real buildings and real sunrises, as opposed to painted sets or theatrical lighting effects. When viewing these images of reality, with their apparent depth of space and continuity of time, you are actually seeing a pattern of light projected onto a flat two-dimensional screen. If you tried to touch the image you would feel the flat screen. A hand placed in the path of the projected light would obliterate this "realistic" image. When a filmmaker tries to recreate three-dimensional space, it is actually an attempt to create an illusion of that space on a two-dimensional plane. The more thoroughly a filmmaker understands concepts such as composition, lighting, continuity and screen direction, the more effective and convincing this illusion will be.

Filmmakers are able to manipulate the way in which space is perceived. Through shot choice, composition, camera movement and editing a filmmaker can make a small room look large, the space between two people look closer than it actually is or create spatial relationships that do not really exist. If the script calls for a tropical beach in the middle of Iowa, the filmmaker can edit a shot of a person walking out the door of a house in Des Moines back to back with a shot of that person emerging from the doorway of a building on a Florida beach.

The perception of time is also easily altered in the filmmaking process. In fact, virtually every narrative film compresses actual time. Most narratives tell a story that takes place over the course of a few days, weeks or even years, but the actual **running time** of a film can range from a few minutes to a few hours. On the screen several hours can be easily compressed into two or three short shots. For example, a sequence of two people having breakfast might begin with a shot showing the couple ordering their meals. This shot could be followed by a close-up of empty plates and coffee cups on the table. The final shot of the sequence might show the waiter bringing the check to the table. One or two hours have been compressed into three shots with a running time of several seconds.

Expansion of time is also used for effect in filmmaking. In Rob Reiner's film *Stand By Me* (1986) four boys make a dangerous decision to cross a long train trestle. As two of the boys reach the mid-point of the trestle, a locomotive approaches from behind. Using a variety of shots, including a long shot of the oncoming train with the running boys in the foreground, medium shots of the boys running, close-ups of the train, close-ups of the boys' running feet and shots of the other boys watching from the end of the

bridge, the 90-second sequence depicts an action (the train crossing the 100-yard expanse) that would normally occur in less than ten seconds.

Closer examination of the sequence reveals that the first three times a cut is made to a shot containing the train, the train is actually almost in the same position on the tracks. The space between the train and the boys is essentially expanded by moving the train back to the beginning of the trestle the first few times it is shown. The shots that do not include the train allow for manipulation of the train's position within subsequent shots.

This raises an important point about the *apparent* continuity within a scene. It is often possible to "cheat," to manipulate the position of people or things within subsequent shots if the shots are separated by another shot or shots. This technique frequently works because viewers tend to perceive film space and time by subconsciously comparing a given shot only to those shots that immediately precede and follow it.

Through shot choice, composition and highly manipulative editing, the filmmaker draws out the suspense and makes the action take much longer than it would in reality. The train scene also contains a long shot in which the boys are running directly toward the camera with the train in hot pursuit. The depth of this shot is compressed because it is photographed with an extremely long lens. The train appears to be almost on top of the boys. In reality the train was much farther from the actors than it appears on the screen. This composition, with its flattened perspective, creates a spatial illusion that is very effective in heightening the suspense and tension within the scene.

Screen Direction

Screen direction is a term used to refer to the direction of movement within the frame or to the direction a character or object is looking or facing within the frame. The camera offers a selectively photographed view of reality. When you shoot straight on at a person as she steps to her right, she will be moving toward the left-hand edge of the frame, or **screen left**, as you look through the camera or watch the projected film. If the individual takes a step to her left she will be moving **screen right**. Because the film frame converts reality to its own two-dimensional space, rules of screen direction have evolved which help maintain directional continuity and the audience's perception of three-dimensional space.

The 180-Degree Rule

A filmmaker must have an idea of the individual shots that will be used to create a scene when preparing to shoot. A scene depicting two people having breakfast might consist of three basic shots; a medium shot showing both people seated at a table and two close-ups, one of each person. In order to shoot and edit this scene effectively it is important to understand the **180-degree rule**.

Within any given sequence the filmmaker establishes an imaginary 180-degree line sometimes referred to as the "axis." This line is established based on the natural line or direction of action within the sequence. The camera's position must remain on one side of that line from shot to shot so that the filmmaker can edit the scene smoothly. All shots are taken from the same side of the 180-degree line. If the camera crosses the line, a mistake in screen direction will occur. In the breakfast scene the director might begin by establishing the line or axis. If two

actors are seated directly across a table from one another the line of sight between the two characters would serve as a natural 180-degree line:

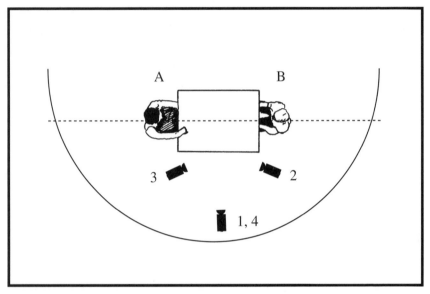

An overhead view showing the 180-degree line and three camera positions for a sequence of four shots. The numbers indicate the order of the shots in the edited sequence.

Suppose the filmmaker creates a four-shot sequence. The first shot is a medium shot of the two people at the table. This is followed by a close-up of character "A," then a close-up of character "B," and the sequence is completed with another medium shot. The series of shots would look like this:

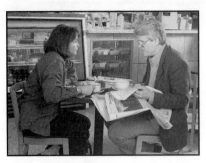

1. MS, both characters

2. CU, character "A"

3. CU, character "B"

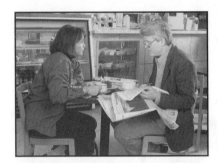

4. MS, both characters

The resulting sequence of shots when adhering to the 180-degree rule.

The overhead view on page 72 shows that the camera positions are all on the same side of the 180-degree line. However, if a shot is taken from a position on the wrong side of the line (see the overhead view and resulting series of shots on page 74) a mismatch in continuity will result:

An overhead view showing the 180-degree line and three camera positions for a sequence of four shots. Camera position 3 is on the wrong side of the 180-degree line.

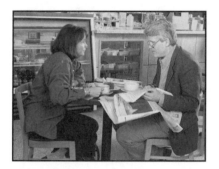

1. MS, both characters

2. CU, character "A"

3. CU, character "B"

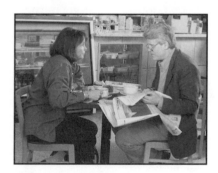

4. MS, both characters

The resulting sequence of shots when breaking the 180-degree rule. In shot 3 character "B" is facing screen right, while in shots 1 and 4 he is facing screen left.

In the close-ups it appears as if the two characters are both looking in the same direction instead of looking at each other. This error in continuity is the result of positioning the camera on the wrong side of the line. To summarize the 180-degree rule, screen direction will be maintained if all shots are taken from one side or the other of the imaginary axis defined by the natural line of action within a sequence.

Changing Screen Direction

At times it is just as necessary to change screen direction as it is to maintain it. In most films the screen action does not move entirely in one direction. In general there are four ways to change screen direction within a scene or sequence.

1. *Changing Direction Within the Shot*
This method for altering screen direction is the most obvious. Simply show the subject changing direction within the shot. Once you have established a new screen direction, you will be concerned with preserving the continuity of the new direction.

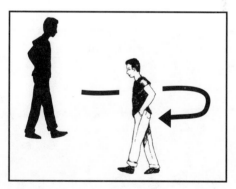

Changing direction within a shot.

Two shots separated by a cutaway shot.

2. *The Cutaway*

If there are two shots taken from opposite sides of the 180-degree line, and you want to maintain believable continuity and avoid confusing the audience, you will want to avoid using these shots back to back. Sometimes, because of the demands of the story, two mismatched shots will have to be used one after the other. A simple way to avoid this dilemma is to separate the two problematic shots by putting another shot (or several shots) between them. An audience watching a film tends to remember and be most affected by the physical relationships between any given shot and the shots that immediately precede and follow it.

A **cutaway** is a shot of something related to but outside of the immediate action of the scene. In the scene of two people eating breakfast a cutaway might be a shot of another person in the room. If you cut from the medium shot of one of the diners to this sort of cutaway, then you can cut to a shot taken from the other side of the 180-degree line without creating a mismatched cut.

Most of the time cutaway shots are used to add detail and meaning to a scene. However, cutaways can also be very useful in masking screen direction mistakes or mistakes in continuity. Filmmakers often shoot cutaway shots (even if they are not really crucial to the scene) to use in case they are necessary to cover problems in continuity or screen direction discovered during editing.

3. *Neutral Angle*

Using the same strategy of separating two problematic shots by putting something between them, a filmmaker can cut to a shot with *neutral* screen direction, favoring neither screen left nor screen right. A **neutral angle** shot is taken with the camera

positioned *on* the 180-degree line. In a sequence of a man walking down the street, the first shot establishes that the man is moving from screen left to screen right:

if the second shot is a neutral angle:

then you can use a shot of the man moving from screen right to screen left as the third shot:

In such a sequence of shots the change of screen direction from the first shot to the third shot is masked by the neutral angle shot between them. The audience understands that the man is continuing to make progress in the same direction, even though *screen direction* has changed.

4. *Camera Movement Across the Line*

If a shot from one side of the 180-degree line must be mixed with material shot from the other side of the line, another way to avoid screen direction problems is to show the change of orientation within a shot. That is, a filmmaker might use a transitional shot that actually shows the changing of screen direction relationships as the camera moves (either on a dolly or handheld) from a position on one side of the 180-degree line to a position on the other side of the line. The audience sees the change in spatial orientation as it occurs and will not be confused when the filmmaker cuts to the next shot, which must now maintain continuity with the new camera position on the other side of the line.

More About Continuity

Apart from making sure the camera stays on the correct side of the 180-degree line, it is also necessary to vary the camera position and/or the size of the subject in the frame. In the sequence of the man walking down the street, if the first shot is a long shot of the person walking along the street and the next shot is also a long shot from approximately the same position, the shots will not cut together smoothly and the action on screen will jump:

But if the position of the camera is significantly altered for the second shot, even if the image size is the same, the shots are more likely to go together smoothly:

If you keep the camera in the same position but significantly alter the image size, once again the shots should cut together well:

It is often best to change both the camera angle and the image size:

<u>Overlapping Action and Master Shots</u>

Finally, when shooting a series of shots intended to be edited together for continuity, the filmmaker should shoot **overlapping action**. In the breakfast scene discussed previously, the first shot is a medium shot of two people. If the second shot is a close-up of a person raising a cup to her mouth, she would lift the cup at the end of the medium shot as well as at the beginning of the close-up. This overlap of action from the end of one shot to the beginning of the next shot provides a range of choices during editing while alowing the editor to maintain the continuity of the action in the scene. If the action is not overlapped during shooting, then the choices available during editing are severely limited. Understanding and applying the principles of continuity during shooting is essential if a scene is going to be edited for continuity.

Frequently, action scenes are shot using a **master shot**. The master shot is a single take of the entire scene or sequence and is usually a long shot that shows the action from beginning to end. Its purpose is to provide total coverage for the sequence, and it is almost always intended to be used in combination with a number of other shots that show various details of the action. While an editor might only use several small pieces from a long master shot, it can be an invaluable source of backup material. If some other shot or shots are unusable for any reason, it is always possible to cut back to the master shot. It is seldom intended to be used in its entirety, and if some part of it is imperfect, it is not usually necessary to reshoot the entire master shot. Some scenes are edited using overlapping action; some are edited using master shot technique; many are edited using a combination of the two.

Chapter 5:
Film Editing

The earliest films were one-shot films. The filmmaker set up the camera and recorded the action as it unfolded in a single long shot. As films became more sophisticated the action could not be contained in one shot, and so several of these uncut shots were joined together to tell the story, each shot being continuous like a scene in a play. Soon filmmakers learned they could break these scenes into pieces or shots that could be put together in an order other than that in which they were photographed. The finished film looked very different from the uncut camera takes. **Editing** is the process of selecting, cutting apart and joining together various shots.

Often a series of shots is necessary to convey information or to move quickly through time and space. In a scene in which someone is reading a letter the filmmaker might choose to make an edit, or **cut,** from a shot of the person's face to a close-up of the letter so that the audience can read it. If the scene is about a process or a progression of action such as building a house, the filmmaker can control the pacing of the action and can direct the audience's attention through editing. Editing enables a filmmaker to concentrate the viewer's attention on the most important aspects of the action.

If you were to observe a man arriving at home at the end of the day, the sequence of action might be quite long. The man drives his car up to the house, shuts off the engine, gets out of the car and locks it, walks to the house, unlocks the door and enters the house. An edited sequence depicting this event doesn't have to

show every detail of the action. If there is a cut from a shot of the car stopping in front of the house to a different shot as the man enters the house, the audience can easily fill in the missing action. These small compressions of time occur frequently in edited sequences and can help the action in a film move at a faster pace.

Although there are many ways to edit a film, every time two shots are spliced together or a piece is cut out of a shot, real time and space are altered to create the time and space of the film. In the sequence of the man entering the house, the editing condenses a specific period of time (the time it takes the man to get out of the car, walk to the house and unlock the door) into a substantially shorter period of time on film. The space is also redefined in that the man can be in the car at one moment and walking through the doorway of the house at the next instant. These ellipses in time and space create a flow of action that holds the audience's interest.

Editing *rhythm* is also important. The rhythm within a scene is created by a number of factors, including the speed and direction of movement within individual shots and the lengths of individual shots. One of the more obvious examples of effective use of editing rhythm can be found in chase scenes. Often in such scenes the shots get shorter and the cuts come faster as the chase reaches its climax.

Invasion of the Body Snatchers, Don Siegel's 1956 low-budget science fiction classic, provides a typical example during a scene in which the film's two protagonists are being chased by a horde of inhuman alien look-alikes who have replaced the townspeople. This 27-shot scene lasts for a little over three minutes. It begins slowly with longer shot lengths, picks up dramatically in the middle of the scene and slows down again toward the end. The ten shots in the middle of the scene, as the chase reaches its climax, have average lengths that are only half as long as the shots that open and close the sequence. In a scene like this, as the pacing and rhythm of the

editing picks up, the audience's heightened anticipation of what is to come next increases the scene's excitement. As the chase winds down the shots become longer and the pace slower, giving the audience time to catch its breath. Of course, rhythm is a factor in every scene. It is simply more pronounced and easier to grasp as a concept in a chase scene.

Editing and Continuity

Often when editing a scene a filmmaker wants time and space to seem to be uninterrupted. If you cut from a long shot of a woman picking up a cup to a close-up as she is drinking from it, you want the gesture to appear smooth and continuous, like a single action, even though two shots (one long shot and one close-up) created the action. A scene in a film might consist of several shots, but the edited result can seem to be a continuous, unbroken sequence of action with no apparent jumps in space or time. **Continuity editing** tries to achieve this smooth, unobtrusive quality. Its goal is to move the film forward without calling attention to the editing process, preserving the illusion of reality that a film creates on the screen.

In good continuity editing the cuts are virtually invisible. This is achieved largely with **match cuts**. Match cuts maintain continuity of action or movement from one shot to the next. They match screen position, timing and direction of movement to create an illusion of continuous movement within a sequence that actually consists of a number of shots. Match cuts lead the viewer's eye across the frame, following the movement of the action and making the edits appear seamless.

Unlike a match cut, a **jump cut** is a jarring cut that calls attention to itself. In continuity editing a jump cut can be the result of an edit between two shots in which there is too small a change in the image size or the camera angle (or both) resulting in a slight, but very noticeable, displacement of the image on the screen. Jump

cuts make the viewer aware of the editing process. They tend to be awkward and can break the film's illusory spell. Of course, there may be times when that is exactly what you want to do.

In order to make a successful match cut between two shots it is necessary to overlap the action during shooting (see Chapter 4, Continuity). Ideally, if time and budget permit, both shots should encompass the entire action and some time before it begins and after it ends. While this is not practical in every case, it does provide the maximum in creative options. You can choose to cut from one shot to the next before the action begins, you can make a match cut in the middle of the action, or you can cut after the action or movement has ended. If the entire action was photographed twice, you will have the ability to cut between the two shots at any point, and you will have greater freedom to consider important factors such as screen position and the direction of movement. There are a number of ways to make a successful match cut:

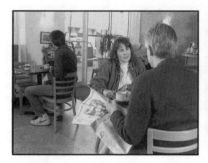

Change the image size significantly: If you cut from a long shot of a woman picking up a cup, in which the whole room is shown, to a close-up in which just her face is seen as she drinks, it is difficult for the audience to notice small continuity differences in the shots, because the image size in the two shots is so different. If you cut from a medium shot to a slightly wider medium shot, there would be little change in image size. Inconsistencies in the woman's facial expression or body position or a jump or a repetition in her movement would be easily detected. Image size can be changed by either moving the camera relative to the subject or by changing the focal length of the lens.

Change the camera angle significantly: The general rule is that a change of camera angle of at least 30 degrees causes a significant enough change in the background and makes any jumps in action at the point of the cut less perceptible to the audience. For example, you might want to edit two close-ups of the woman back to back. If the first one is shot facing her straight on, shoot the second one from an angle off to one side.

Cut on action: Usually the best place to make the edit is while the woman is picking up the cup. The movement of her hand catches the viewer's attention, and moves the viewer's eye smoothly across the frame. When cutting on action it is important to be aware of, and to maintain, both image placement and the direction of movement from one shot to the next. By effectively matching the position and direction of physical movement from one shot to the next, *across* the cut, your editing will become more fluid.

It is usually best to use a combination of these guidelines. Often it is most effective to change the image size and the camera angle while cutting on action. Sometimes, even if you are following these guidelines, no matter how you try to cut them, two shots will not work together smoothly. In the example of the woman drinking, the woman's head position might be significantly different from one shot to the next shot. Details of the set or her costume might have changed. In this situation you might use a cutaway shot to try to preserve the continuity of the scene. You might cut from the long shot to a shot of another person in the room and then to the woman's close-up. Since the shot of the newspaper doesn't involve any of the details of the main action that the other two shots have in common, it provides a possible way to avoid a bad cut that interrupts the flow of action and breaks the cinematic illusion.

When edited for continuity most scenes include, within the first few shots, an **establishing shot** in which everyone and everything is shown in relation to everyone and everything else. This is almost always a long shot and its purpose is to define the physical space. Once the space has been established the filmmaker is able to break it down into a variety of shots including close-ups and medium shots. If spatial relations change significantly later in the scene (perhaps someone else enters the room) the filmmaker usually returns to another establishing shot so that the audience can see the new spatial relationships. Establishing shots are also frequently used as a transition to a new scene.

These editing techniques give the filmmaker the maximum range of choices when cutting a scene for continuity. If you are careful, plan your shoot in advance and cover the action in several shots, you will give yourself the opportunity to be creative in the editing room instead of being limited to only a few shots that can be edited effectively.

Alternatives to Continuity

Continuity editing is only one approach to editing, one that works best in certain types of films, particularly in conventional narrative films. In documentaries continuity editing is not usually necessary or even desirable. If the Boston Marathon is the subject of a film, the runners can't be expected to repeat their actions after a change of focal length or camera angle. Various editing styles and techniques have been developed by filmmakers who sought to exploit film's ability to manipulate time and space in more pronounced ways.

Parallel editing is an editing technique that involves cutting back and forth between any two (or more) scenes or actions in order to suggest that these events are happening at the same time. Parallel editing is widely used and is very effective in establishing and building dramatic tension. Virtually every action movie makes use of parallel editing. The concept is simple. Two events, supposedly occurring simultaneously, are depicted by cutting back and forth between them a number of times. Every time it is shown, each event unfolds a little further. It seems as if both events are happening at the same time. In the well-known final sequence of Mike Nichols' *The Graduate* (1967) the main character, Ben Braddock, is racing to stop his girlfriend Elaine from marrying another man. The sequence was edited by cutting back and forth between shots of the wedding ceremony progressing and shots of Ben trying desperately to reach the church in time to stop the ceremony. The back-and-forth editing creates the sense that the two actions are occurring simultaneously.

In *The Godfather* (1972) Francis Ford Coppola makes good use of parallel editing in another kind of sequence. As Michael Corleone stands in a church witnessing the baptism of his godchild, Coppola cuts back and forth between shots in the church and various shots of Corleone's enemies being brutally slaughtered by his hit men. This memorable sequence conveys a sense of horror and irony as the shots of an angelic Michael Corleone are quickly intercut with shots of the bloodbath he has engineered.

In the example from *The Godfather*, parallel editing is used in conjunction with **montage** editing. The term "montage" is commonly used to describe virtually any sequence comprised of many brief shots. But montage is more than just a lot of quick flashy cutting. The juxtaposition of shots in a good montage creates meaning that the individual shots cannot convey alone. Nicholas Roeg's 1973 film, *Don't Look Now,* involves a character who has visions of the future but doesn't recognize them as such. The film's final sequence includes an extended montage of about 100 seconds' duration and more than 60 shots. While the protagonist lies bleeding on the ground, many of the film's ambiguous but haunting images are tied together as they flash through his mind. Images of the present, his memories of past events, his previously misunderstood visions of the future and his visions of a future yet to come all converge on the viewer in a rapid-fire sequence that is the key to understanding the entire narrative. Most of the shots in this sequence already have a context within the film. Presented in this way and in this order, they achieve new meaning.

Montage is very different from the invisible editing of the continuity technique. Montage tends to emphasize the cuts, creating a visual collision of shots. The famous shower murder scene in Alfred Hitchcock's *Psycho* (1960) is a montage sequence of more than 70 shots edited into approximately 45 seconds of screen time. The terrible violence of the scene is not conveyed by the content of individual shots. There are few shots in the scene which contain both the victim and the knife and only one shot in which the knife appears to touch the victim's body. The stabbing is created through editing in which repeated shots of the knife flashing through the frame are quickly intercut with shots of the victim's reaction. The narrative content of the scene, the slashing of the victim, is visually amplified through the violent cutting of the film itself.

Any editing style implies that some actions or pieces of time are more important than others. The actions that are shown are obviously given greater importance than those that are not shown. In the "long take"

style of filmmaking no single moment is intrinsically more important than any other. Rather than cutting shots into pieces and only using some of these pieces, the filmmaker uses long, uninterrupted camera takes, keeping the seemingly insignificant moments as well as the important ones. Mike Figgis' film *Time Code* (2000) consists of four 90-minute, uncut shots shown simultaneously on the screen. The resulting film is much slower than a tightly edited film like *Run Lola Run* (1999). It is a film in which the awkward silences and boring moments are as important as any dramatic moments. Some of Andy Warhol's early films, like *Empire* (1964) and *Vinyl* (1965), take this style to the extreme. In these films all of the film that was shot is included, even the fogged ends of each roll of film. It is the *absence* of editing, the apparent lack of manipulation, that makes the long take approach a unique editing style.

Film Editing Mechanics

In one sense editing is a simple set of mechanical actions. When making a super-8 film or a 16mm reversal film the filmmaker usually projects the original uncut footage, called **rushes,** and selects the best takes. If the film is being shot on 16mm negative, then the rushes will be a positive workprint made from that negative. Rushes are sometimes referred to as **dailies,** and the terms are used almost interchangeably, but technically, only a workprint should be called dailies (see Chapter 2, Film Stock). In the editing room the rushes are screened again on an editing **viewer,** and the selected takes are marked for cutting. Using a **splicer** entire shots are cut out and hung up in the approximate order that they will appear in the final film. The unused takes that remain are called **outtakes.** Once the selected shots are arranged in order, they can be taped together, or **spliced,** into an **assembly.**

An assembly is the first rough edit of a film. Since it consists of entire takes that have been spliced together, the assembly will contain repeated action that needs to be cut out. Since no cuts have been made within shots at this point, close-ups ultimately

meant to be inserted into the middle of a long shot can simply be spliced in after it. After viewing the assembly and evaluating the film's basic structure it can be edited, putting pieces of various shots into their proper places and cutting out parts of shots that are not needed. The frames of film that are cut from the selected shots throughout the editing process are called **trims**. They should be stored on a "trim reel," separate from the outtakes. Often a filmmaker decides to lengthen a shot or shots after viewing an edited scene. It is important to keep trims, because they are essential in making these adjustments.

Once shots have been edited into their basic order, the film can be considered a **rough cut**. At this point the film should be projected again. It is important to project the film frequently during the editing process. Watching it on a manual viewer certainly will not give a true sense of the pacing of shots and cuts as they will appear when the film is projected, and even a motorized editing machine (like those made by Steenbeck and Moviola) that runs at 24fps shows the film on a small screen. Small mistakes are easier to see when projected on the big screen than on the small screen of the viewer or editing machine. When the shots have been edited to exactly the right length and the pacing and rhythm of the film have been established, the rough cut has become a **fine cut**.

If the camera original has been edited and is intended to be projected, then creative editing is complete and the film can be prepared for presentation. It is a good practice to put several feet of white **leader** (blank white film) at the **head** (the beginning) of the film and several feet of white leader at the **tail** (the end). This will help protect the edited footage. A generous amount of head leader allows for the threading of the projector and will prevent the film from being damaged in the event of a bad feed into the projector. It is also a good idea to include some black leader at the head and tail of the film. Splice a few seconds of black leader between the white head leader and the first image of the film, and put another few seconds of black leader between the last image of

the film and the white tail leader. The black leader will cause the screen to go black before the first image or title appears and after the film's final image. Visually, this is a better opening for a film than cutting from the bright, white leader to the first shot. Including black leader at the end, after the last shot or title, is also more visually effective than going right into the white leader.

Once the head and tail leaders have been spliced into place, they should be labeled for identification purposes. Each white leader should be marked "head" or "tail," followed by the film's title and your name and phone number. If it is a super-8 film, the intended projection speed (18 fps or 24 fps) should also be written on the head leader. It is important to label the tail leader as well as the head, because often films are left "tails out" (not rewound back to the head). If you should happen to misplace or lose a film and it is tails out without labeling, the chances of the film being returned are slim.

If a filmmaker has edited a workprint rather than the camera original, then before the film can be finished the camera original must be conformed to match the edited workprint. **Conforming** is the process of carefully cutting the camera original to match the edited workprint frame for frame. The film is conformed by using the **latent edge numbers** that appear outside the picture area along one edge of the strip of film. Latent edge numbers are a set of numbers that are photographically incorporated into 16mm and 35mm (but not super-8) film stock during manufacturing. Latent edge numbers are numerically progressive. A new latent number appears every 20 frames on 16mm camera original, regardless of whether the original is negative or reversal. When the film is processed the latent edge numbers become visible. When a workprint is made the edge numbers are also printed onto the edge of the workprint so that the workprint is not only a frame-for-frame copy of the image, but an exact copy of the edge numbers as well. The filmmaker can then look at the edge numbers on the edited workprint and use those numbers to cut the exact frames needed from the negative.

The conformed camera original is taken to a film laboratory where it is used to create an **answer print**. An answer print is the first finished print of an edited film and it contains no splices. If the camera original has been handled properly during conforming, the answer print will be free of dirt and scratches. When a film is printed, the laboratory has the ability to make some limited corrections to the color and exposure of individual shots. Such adjustments are known as **timing** changes. Once the filmmaker has projected and approved the answer print with all its corrections, additional prints, called **release prints**, can be made from the camera original if necessary. All of the timing changes approved in the answer print will be incorporated into the release prints. Release prints are considerably less expensive than the answer print.

Fades and Dissolves

Frequently shots may begin or end with a **fade-in** or a **fade-out**. A fade-in is a transition in which a blank (usually black) screen gradually reveals an image until that image is fully realized on screen and is often used to begin a scene. A fade-out is a transition in which a shot at full value gradually diminishes to a blank screen. Fade-outs often occur at the end of a scene and are generally used to suggest a passage of time.

A **dissolve** is a transition in which it appears as if one image blends into another image. A dissolve is actually a fade-out occurring simultaneously with a fade-in. Transitions can occur at various speeds. A 24-frame fade or dissolve will have a duration of one second, a 48-frame transition will occur in two seconds, a 96-frame transition will take four seconds and so on. Fades and dissolves are effects that are normally created in the film laboratory when the answer print is made. Many labs don't charge any additional fee for fades and dissolves as long as standard lengths (16, 24, 48, 64 or 96 frames) are used. Some labs charge a relatively small one-time fee for standard-length fades and dissolves, but it applies only to the answer print. There is no charge for fades and

dissolves in the release prints regardless of the number of prints being made. Some 16mm and super-8 cameras allow the filmmaker to create fades or dissolves in the camera, and while these effects are usually less precise than film laboratory effects, it can be a useful feature for a filmmaker who doesn't plan to make a print of his film.

Cleaning

Before screening the film for an audience, you should clean it. You will need film cleaner and a lint-free cloth or film wipe to do this. Clean the film on rewinds or place it on an editing viewer, but do not thread it through the viewer's gate. Hold the cloth in one hand and apply a small amount of cleaner to it. By lightly pinching the damp cloth around the film with your thumb and forefinger both sides of the film will come into contact with the area of the cloth that is moistened. Turn the take-up reel slowly, pulling the film through the cloth. It is important to wind the film slowly enough to allow the cleaning fluid to evaporate from the film's surface before the film is wound around itself on the take-up reel.

Cleaning film

After winding for a few feet check the cloth and you will see that it is removing dust, grease pencil marks and other dirt. When the cloth has become sufficiently dirty, stop and find a clean area on the cloth. Apply more cleaner and repeat the process until you reach the end of the film. When working in super-8 or 16mm reversal you will almost always be editing your camera original film rather than a workprint. Because of this it is especially important to clean the dirt from the film periodically, since dirt on the film will ultimately lead to permanent scratches which can't be removed. Always use film cleaner in a well-ventilated area, since the fumes can be toxic. It is also advisable to wash your hands immediately after using film cleaner.

Storage

Film will last for many years if it is stored properly. There are a few important guidelines to follow. Tape down the end of the leader so that the film will not unravel or become loose on the reel. Never pull on the end of a loose roll of film to tighten it, since this can result in "cinch marks." Cinching is a type of scratching that occurs when one layer of film rubs against another, and pulling on the end of a roll of film can create cinch marks throughout the entire roll. Store the reel of film in a plastic or metal can or some other light-tight, dust-free container. For long-term storage plastic reels and cans are preferable to metal ones. Films should always be stored in dark, cool, dry places. Avoid hot attics, wet basements or other areas that might subject a film to extremes of heat or humidity.

Video Transfer

Frequently filmmakers transfer motion picture film to videotape. There are various reasons to transfer film to tape and several transfer methods. Shooting on film, then editing on videotape or a computer is common for commercials and television programs. Super-8 filmmakers often transfer their rushes to video for editing, and the finished product is released only on videotape.

Feature films are now frequently edited using a computer and the camera original is cut to match this digital edit. This production technique allows the filmmaker to combine the superior rendition and tonality of the film image with the ease of digital editing. When a filmmaker is working with camera original such as super-8 or 16mm reversal film, editing on videotape will decrease wear and tear on the footage. (The processes involved in computerized editing for a film are discussed in Chapter 6, Digital Editing.)

Finally, video copies of a work released on film are useful for grant applications, film festival submissions and viewing by family and friends. Especially when the finished film is camera original material, the loss of image quality in the video copy can be partially offset by the convenience of video viewing. Video "dubs" can be given to actors and crew members as payment for their participation in the film.

The least expensive method of transferring film to tape is to videotape the film off of a small screen. In a dark room, project the film onto a smooth, non-glaring white surface (copier paper works well). Keep the projected image small so it will be as sharp as possible. Position a video camera on a tripod as close to the projector as possible and make sure both projector and camera are focused properly before taping. Using this technique the quality of the transfer will depend on the type of projector used, the quality of the video camera and the video format. There are many video formats including VHS, super VHS, Hi-8, MiniDV, DVCam, DVC Pro, Betacam SP, Digital Betacam, D-1, D-2, D-3 and D-5. The Betacam and "D" formats will give the highest quality results, but it is common practice to use a mid-range format like S-VHS or MiniDV for off-the-screen taping.

Many photographic supply stores offer a film-to-tape transfer service. The local photo store might send the footage out for transfer or they might do it in house. They will almost always transfer film to videotape using a **film chain**. A film chain uses a video camera

and a film projector with a mirror set at a 45-degree angle between them. The mirror directs the projected image into the lens of the camera as the footage is recorded onto the videotape. The iris of the video camera is usually fixed at a single setting, so variations in exposure on the film cannot be corrected. Alternately, as the brightness of the film image changes, the iris of the video camera can be adjusted "on the fly," but this results in momentary problems with exposure.

By far the best results are achieved with a **telecine** system, a more sophisticated electronic transfer. This type of video transfer is much more expensive than a film chain transfer, but it is the only system that provides the opportunity to manipulate the color, contrast and brightness of individual shots as they will appear on tape. Many professional motion picture laboratories offer electronic transfer of film to videotape. These transfers are commonly made to the Betacam SP or D-2 formats when the tape is intended to be used as a master for making multiple dubs. However, when making a transfer in order to edit on tape the choice of format depends upon the format of the editing system that will be used.

When shooting film that will ultimately be exhibited on videotape the filmmaker must carefully control the lighting contrast. A video transfer of film will always have higher contrast than the original footage. Film shot for transfer to tape should have a relatively low lighting contrast ratio (see Chapter 8, Lighting). Framing and composition are also important considerations since a television screen crops the image differently than a film projector does. Many motion picture cameras have a TV screen demarcation visible in the camera's viewfinder. When shooting film that will be exhibited on tape, the filmmaker must be careful to compose shots within this "TV-safe" area.

Chapter 6:
Digital Editing

The power and wide availability of personal computers have increased the number of options available to filmmakers. While computers offer great advantages in speed and flexibility, they also introduce some extra steps into the filmmaking process. The capabilities of the computer can be applied to filmmaking in many ways. This chapter focuses on computerized editing. In broad terms this process includes **input**, **digital editing** and **output**. Input involves getting material into the computer while converting pictures and sounds into **digital media files** that a computer system can store and manipulate. Digital editing is the process of selecting, joining together and trimming various shots, using the computer. Output is the process of getting the edited material back out of the computer so it can be shown on film, videotape or other media.

Input

In order to edit a film using a computer system, film images and sound track audio must be converted into digital media files that a computer can recognize and work with. It is possible to transfer film directly to digital media files utilizing a system such as Kodak's Cineon format, which produces high quality files ready to be input into a computer editing system. It does this by individually scanning every frame of film. This process might be used for sequences that involve digital special effects in large-budget, effects-laden films such as *Titanic* (1997) and *The Matrix* (1999). However, this is an expensive process (particularly during the output stage) and it produces large cumbersome files. A more affordable and more common method of bringing film images into the computer is to

first transfer the film to videotape. Once the footage has been transferred to videotape, it can be **digitized**, or converted into digital media files that a computer editing system can accept. Audio tracks can also be transferred to the videotape and digitized in synchronization with the picture.

When editing on a computerized system the filmmaker usually requests **video dailies** from the film laboratory instead of, or in addition to, a film workprint. Video dailies are a special type of film-to-video transfer that will be digitized for editing. Image quality is less important for video dailies than for exhibition-quality video transfers. Like a film workprint, video dailies are a rough copy of the original camera footage to be used solely for editing purposes. Video dailies must contain special frame identification information that ordinary film-to-video transfers do not contain. This is because the process of transferring film to tape before digitizing introduces some incompatibilities. The most significant problem arises from the difference in frame rate between film, which runs at 24fps, and **NTSC** (National Television Systems Committee) video, which runs at 29.97fps. The video frame rate is often referred to as 30fps, but this is simply rounded up from 29.97. In order to compensate for the difference in frame rate, film shot at 24fps is transferred to videotape using a method called **pulldown**.

Pulldown is a transfer method in which film frames are copied onto multiple video **fields** in order to make the images on the videotape precisely match the speed of the images on the film being copied. A video frame consists of two sets of electronic horizontal lines, and there are nearly 30 frames (exactly 29.97) each second. Each *frame* consists of two *fields*, one composed of all the even-numbered lines and one composed of all the odd-numbered lines. Each field holds half of the image information for a given frame. Since the fields are presented so quickly when video is shown, our eyes put the fields together due to a phenomenon much like persistence of vision (see Introduction: The Moving Image).

The most common method of converting film to video is **3:2 pulldown.** This process recognizes and takes advantage of the fact that each video frame is divided into two fields. Using the 3:2 pulldown transfer method, the first film frame is recorded onto three fields (1.5 video frames). The next film frame is recorded onto two fields. The next film frame is recorded onto three fields, and the following film frame is recorded onto two fields. This process converts four film frames into five video frames, changing the frame rate from the film's 24fps to 30fps on videotape. In addition, the film is slowed down by 0.1%. The 3:2 pulldown in combination with this 0.1% slowdown converts film from 24 frames per second to video running at 29.97 frames per second.

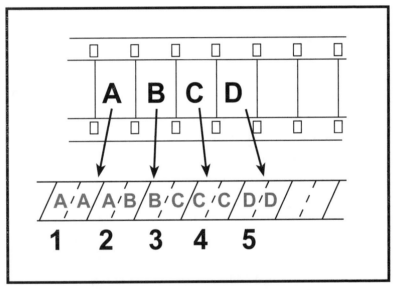

3:2 pulldown. Four film frames are converted to five video frames. Film frames A and C are each recorded onto three video fields, while film frames B and D are each recorded onto two video fields.

Once the film has been transferred to video it can be digitized into the computer editing system. If you intend to finish the project on videotape rather than on film the differing frame rates will not be of further concern. If you plan to finish on film there must be

a way of repeating with the original film footage the edits that were made in the computer. You must be able to match the video, edited at 29.97fps, to the film which will be projected at 24fps. A filmmaker also needs to understand different frame identification codes in order to thoroughly grasp this process.

Each roll of 16mm and 35mm film has identifying numbers, latent edge numbers, printed on the edge of the camera original footage (see Chapter 5, Film Editing). The footage also has a machine-readable bar code form of edge numbering called **keycode** along its edge. On videotape each video frame is assigned a number using **SMPTE time code.** SMPTE (Society of Motion Picture and Television Engineers) time code uses a specific number for every frame on a tape so that video editing can be frame-exact. The time code numbers exist on a special track, and they can be visible on the screen or hidden. These video time code numbers are different from the latent edge numbers and keycode numbers found on the camera original footage. The video dailies should include both time code and keycode information. It is critical when the transfer is made that the keycode information is precisely accurate. After editing is complete this information will be used to conform the original camera footage to the computer edit, a process known as **matchback.** Some computerized editing systems have built-in capabilities to match time code and keycode so that matchback will be accurate. Some sophisticated systems such as the Avid Film Composer will even remove the pulldown to recreate the original 24fps film frame rate. Other more affordable systems need to use extra software designed to track both sets of code and keep them consistent throughout the edit.

It is important to **log** video footage before it is digitized. Logging is the process of giving each shot an identifying name, noting the reel that it is on, noting the shot's beginning time code number and its overall duration and writing a brief description of the shot. The log allows the editor to better identify shots and organize material prior to the edit. When logging, keycode information

should also be entered into the editing system or matchback program. Many editing systems have logging programs that create a log in the exact format that the system requires. After the video material has been logged it can be digitized.

Digitizing involves playing a videotape while simultaneously "recording" it as digital information onto the computer's hard drive. Because hard drive storage is almost always limited, it is important to be able to thoughtfully select those shots, takes or portions of takes that will be digitized. Most systems allow the user to selectively choose entries from the log, giving the computer instructions to digitize only those segments. Much of the footage selection process takes place prior to actually digitizing. In addition, many systems use **compression** in order to store more footage in less space. Compression involves mathematically reducing the size (and quality) of the digitized files so they take up less space on the hard drive.

Audio is digitized in much the same way as picture regardless of whether the sound comes from videotape, from field recordings or from other sources. Care must be taken that audio is played back at the correct speed and that sound maintains its synchronization with picture. All digitized picture and audio ultimately ends up as digital media files on the computer's hard drive, and each digital media file has a name and a description taken from the log. These digital media files are available to the editor to use in creating the edit.

Editing

There are many computer editing systems available, and new programs are constantly being introduced. The following is a general discussion. When using a digital system consult the operating manual for specific details on how that system works.

Most computer editing systems are designed to be familiar to an editor. The **interface**, or the on-screen configuration, of nearly every computerized editing system is intended to imitate equipment and processes a film or video editor would recognize. While the visual and audio material consists of digital media files on the computer's hard drive, those files are commonly referred to as **clips**. The clips are made available in a computer folder on the screen, and the folder is often called a **bin**. Film clips, trim bins, monitors and "cutting" and "splicing" controls are among the on-screen tools that computerized editing systems use to create an edited program.

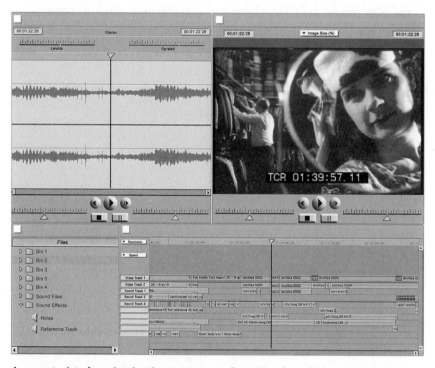

A computer interface showing the on-screen configuration of a typical computerized editing system. The bottom, right-hand window is the timeline.

Most of the actual process of editing on a computer is carried out in an area of the screen called a **timeline**. The timeline contains several horizontal tracks that are used for the placement of picture and audio material which constitutes the final edited project. Icons on the timeline's tracks refer to specific portions of the actual digital media files that reside on a hard drive. The timeline controls allow an editor to play the edited project, to go to specific locations in the edited work and to make changes to the edits. Different types of tracks are used in the timeline. Video tracks contain the picture material. More than one video track is usually available. This allows for transitions such as fades and dissolves as well as other more elaborate visual effects, but a filmmaker intending to finish a project on film rather than videotape will usually only want to use one video track. Audio tracks are the sound tracks. Most systems allow a large number of audio tracks that can be played back simultaneously, up to the limits imposed by the computer's memory. Tracks can usually be activated or deactivated, shown or hidden, or played solo with all the other tracks turned off.

Editing a scene in the computer involves choosing a clip from a bin (like selecting footage from a film bin), choosing a beginning and ending point within the clip and positioning the selected portion of the clip (or shot) on the timeline. The beginning and ending frames that define the portion of the clip to be used are referred to as **in points** and **out points**. Most systems are designed to play through a clip on one screen or window, usually called the source monitor, in order to select in and out points. The selected portion of the clip is placed on the timeline at the desired location. As clips are positioned on the timeline a sequence is created. The edited sequence may be viewed by "playing" the timeline on a separate screen or window called the program monitor. The sequence progresses from an assembly to a fine cut by adding clips to the timeline, deleting clips from the timeline, repositioning clips and trimming.

Most editing programs use two methods of adding new clips to a timeline in order to build a sequence. Using an **overwrite edit** the new material covers existing material on the selected portion of the

timeline, replacing it. An **insert edit** places new material on the timeline and shifts any existing material forward on the timeline from the designated edit point. Insert edits are sometimes called "ripple" edits, since the position of material already on the timeline is shifted. This is comparable to splicing a new shot between two existing shots in an edited film sequence. In a computerized editing system, overwrite and insert editing work like word processing programs that allow a writer to either replace or insert text at any point in a paragraph.

Clips that have been placed on the timeline can be freely cut and pasted or moved forward or backward within the timeline, just as text in a word processing program can be moved around. While clips can also be easily copied, filmmakers who plan to finish on film should avoid using the same digital file more than once, since each digital file corresponds to specific physical frames of film. Clips can be trimmed once they are on the timeline, lengthening or shortening a shot at either its head or tail. The choice of overwrite or insert mode determines the way in which trimming affects the edit. Lengthening a shot in overwrite mode replaces footage from the shot next to it. Shortening a shot results in empty spaces on the timeline. In insert mode lengthening or shortening a shot causes footage that occurs later in the timeline to move forward or backward so that no footage is replaced and no gaps are created. During trimming, especially in insert mode, it is important to be sure that audio tracks maintain synchronization with picture tracks. Video and audio tracks can be activated or deactivated on the timeline. Operations such as bringing a clip onto the timeline or trimming a clip only affect the activated tracks.

Most editing systems provide the editor with a large number of audio tracks. All editing operations work on audio tracks as well as video tracks. Many editing systems also allow the editor to adjust the audio volume and characteristics in sophisticated ways. Some systems indicate whether audio has slipped out of synchronization with its corresponding picture track.

Transitions and Graphics

The simplest transition from one shot to another is the cut, created when sections of clips are placed beside each other on the timeline. Fades, dissolves and other more elaborate transitions are possible. Often editing systems treat these types of transitions as effects, sometimes using separate effects tracks to define them. Creating a fade or a dissolve can be accomplished with the click of a mouse, but it is important to be sure that the transition can be recreated when the finished edit is matched back to the original film footage. Fades and dissolves should be done in standard frame lengths that a film laboratory printer can perform, usually lengths of 16, 24, 32, 48, 64 or 96 film frames. Other more elaborate visual effects, will have to be created on film using an optical printer increasing the expense and time involved in post-production.

Similarly, one of the temptations of the computer is the ease with which graphics can be created and manipulated. Even modest editing systems often have the capability to create superimposed titles, credit rolls and images that include transparent areas that can allow underlying footage to show through. All of these graphics require expensive optical printing processes if they are going to be recreated on film. Simply shooting graphics or titles from the computer screen will result in unacceptably poor image quality. If you plan to finish on film, the best solution is to create all of the graphics and optical effects on film.

Output

Once editing is complete the project must be output to its final distribution medium: computer readable files, video or film. Most editing systems can export the picture and sound as computer-readable files. These types of files might be needed if the film is going to be used as part of a web site or DVD-ROM project. Outputting onto videotape requires playing back

the edit while recording it using a videotape recorder. Some systems can control the recorder and can create a master videotape complete with specific time code, color bars and tone (test signals that allow accurate playback of the tape). This feature, usually referred to as "printing to tape," is useful if the film is going to be distributed on videotape. The master videotape should be made on a high-quality tape such as one of the Betacam or "D" formats.

If you plan to make a film answer print, then it is not necessary to output the images at all. Each of the final editing decisions, including in and out points both in the source material and on the timeline, along with the type and duration of any transitions and effects, are contained in an **Edit Decision List (EDL)**. The edit decision list, rather than the actual picture, is output from the computer. The SMPTE time code information in the EDL must be matched back to the latent edge numbers and keycode of the original camera footage so that each shot in the film will contain exactly the same frames as those in the digital edit. Some computerized editing systems have this matchback capability built in. Others must rely on separate software programs that accept an EDL and match that information with the film's original keycode data. In either case, the end result is a list of latent edge numbers that can be used when conforming the camera original film in order to reproduce each of the edits precisely.

If the answer print will have a soundtrack, audio must be output in a form the film laboratory can accept. This involves playing back the tracks from the computer system while recording the mixed audio onto a suitable audio format. (For a discussion of audio formats and mixing see Chapter 9, Sound.) The audio tracks must be sped up 0.1% during output, since the picture and any associated synchronous tracks were slowed down by that amount when they were digitized, and all additional audio tracks will have been built in relation to the slowed down picture.

Chapter 7:
Pre-Production

The filmmaking process is divided into three phases: pre-production (the planning of the film), production (the actual shooting) and post-production (editing and laboratory work). In many ways the pre-production phase is the most important of the three. When the making of a film is properly planned the shooting and editing will be less hectic and more efficient.

Writing the Film

A film begins as an idea. While initially a film might grow out of a simple concept, the basic idea is often developed into a more and more complex construction. When describing an idea for a film a filmmaker might write a **proposal** that explains what the film is about and what kind of a film it is going to be. This proposal might be written for a potential funder, for a filmmaking teacher or simply for the purpose of clarifying the film's concept. The proposal can be as short as two or three paragraphs describing the subject matter, the basic idea and the stylistic approach to the material.

After a proposal is written the film's concept must be combined with the structure which best fits that concept. In a film **treatment** the idea is described in more specific terms. The written treatment concentrates on the film's structure and the most effective presentation of the material. It often includes a general description of each character in the film as well as a short statement outlining the filmmaker's intent. A treatment for a documentary or an experimental film might emphasize the filmmaker's point of view

or approach to the material. In a narrative film the treatment usually presents the plot scene by scene but not shot by shot. It describes the important events that advance the plot within each scene. A treatment for Citizen Kane might begin like this:

Scene 1. The mansion of the wealthy Charles Foster Kane. Kane, old and bedridden, dies. His last word is "Rosebud."

Scene 2. A newsreel summarizing the important events of Kane's life. These events will be shown in greater detail and from a more personal perspective later.

Scene 3. A screening room. Unhappy with the newsreel, the newsreel producer orders a reporter to find out what "Rosebud" means.

And so on for every scene in the film. Dialogue and details of actions are not included in a film treatment. At this point all that is important are the twists of the plot. The treatment describes concisely what happens in the film and the order in which events unfold.

Much more planning is still necessary. Few filmmakers would begin to shoot with just a treatment. The next step, when making a narrative film, is writing a more detailed **script** or **screenplay**. The script contains all of the scenes from the treatment. Each scene is written to include all of the relevant action and dialogue. Scripts are also written in a specialized format so that certain kinds of information, most of it necessary for planning and scheduling, can be found easily. A properly formatted scene in a script might look like this:

4. INT. BEDROOM - NIGHT

JUSTIN is sitting on the edge of the bed watching as PAIGE
packs her clothes into an old suitcase.

<div align="center">

JUSTIN
You're leaving then?

PAIGE
I can't believe you neutered Scott.

</div>

Paige finishes packing and walks out of the room. Justin
remains seated on the bed. The front door SLAMS.

5. EXT. HOUSE - NIGHT
Paige walks away from the house carrying her suitcase. It
begins to RAIN.

And so on for every scene in the film. Several aspects of the format are worth a closer look. Each scene is numbered, making it easy to identify and refer to individual scenes during the planning stage as well as during the shooting and the editing of the film. After each scene number the scene is designated as an interior ("INT") or an exterior ("EXT") location. This helps in planning the shooting schedule. After the "INT" or "EXT" designation the location is given, followed by the notation "DAY" or "NIGHT." This top line provides most of the important information about the scene needed for scheduling: whether it takes place inside or outside, where it takes place and at what time of day it's supposed to occur. The first time a character's name appears in the script, it is typed in capital letters. After that it is written normally within the body of the script. When a character is speaking, the character's name is always typed in capitals and it is centered on the page, setting it apart from the body of the script. The character's dialogue is centered under the name. These aspects of the format allow a reader to skim through the script to see how many different characters appear in the film or to look at an individual scene

and quickly identify which characters have speaking parts. Any sound effects that are described in the script are capitalized. This sort of information is useful in planning and scheduling for production.

A script does *not* include shot descriptions, camera angles or directions for camera movement. The script is for other people (actors, crew, funders and so on) to read, and it is too time consuming and distracting to get through a long script with all of the shooting details included. After the script has described what will happen in front of the camera, the director decides where the camera will be placed, what types of shots will be used and how they will be composed. This information is detailed in a **shooting script** and also in a **storyboard**.

The shooting script describes every shot, every camera angle and every movement for each scene in the script. Since the shooting script is mainly for the use of the director and the cinematographer, format isn't as important as it is in the script. A shooting script for the scene previously described in script form might look like this:

4. INT. BEDROOM - NIGHT
 1. LS bedroom. Justin is sitting on the bed watching Paige pack.
 2. MCU Justin looking at Paige.
 3. MS Paige packing.
 4. CU Justin: "You're leaving then?"
 5. CU Paige: "I can't believe you neutered Scott."
 6. CU Scott, dazed.
 7. MS Paige finishes packing. PAN with her as she walks out the door. Continue PAN from door to MS Justin. The front door SLAMS.

One problem with scripts and shooting scripts is that they are written descriptions of visual images. In a storyboard the filmmaker sketches a frame to represent each shot in the shooting script. This enables the filmmaker to visualize what

the shots will look like rather than relying on a written description of them. The storyboard also provides greater detail. For instance, "MS Justin" could look like this:

or it might look like this:

A storyboard is similar to a comic strip version of a film and, in fact, comic book artists often work as professional storyboardists. However, since a storyboard's main purpose is to serve as an aid in planning a shoot, it does not need to be slick and well drawn. What is important is that the overall spatial relationships, image sizes and screen directions are clear from the drawings. Even if

your drawings are simple stick figures, you can create a useful storyboard that shows proportionate image sizes, camera angles and the direction people are facing in each shot. Consider the following storyboard based on the shooting script on page 111:

1. LS Bedroom.
Justin watches as Paige packs.

2. MCU Justin.

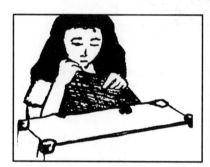

3. MS Paige packing.

4. CU Justin "You're leaving then?"

5. CU Paige "I can't believe you neutered Scott!"

6. CU Scott, dazed.

7a.
7b.

7c.

MS Paige finishes packing. PAN as Paige moves to door. Continue PAN to MS Justin sitting on bed.

Some films do not require all of the scripting phases that have been outlined. A very short film might go straight from treatment to storyboard to production, skipping over the script and the shooting script. It might be impossible to create a detailed treatment for some documentary films. The nature of most documentary films is that the actions that occur in front of the camera cannot be predicted. Certain experimental films and some kinds of documentaries can be approached in a more freehand way, without knowing ahead of time exactly what you want. Writing treatments and scripts for such productions can still be quite useful though. A written description of what the film *might* be can help the filmmaker to imagine and anticipate situations and can provide the filmmaker with a potential structure, so the approach to the material will not be random. In such cases production can become

a process of exploration and discovery. This approach requires a lot more film, money, time and effort to create a unified film out of what was shot at the spur of the moment, and it involves a lot of risk, but the rewards can be great too. Generally, the less work you do in pre-production, the more work you will have to do in post-production to make a film succeed. In many cases the lack of proper pre-production creates an insurmountable obstacle to the creation of a successful film.

Preparations

Depending on the length, scope and specific details of your project, you are likely to need more than just a camera and some film to shoot it. Even small films usually require some sort of technical crew during production. The crew might be as small as two or three people, or a crew can be extremely large. It is important to form an appropriate crew during pre-production. You will need to find people with the right kind of expertise (camera, sound, lighting and so on) with whom you will be able to work and communicate with. You will also need to find people who are willing and able to commit the time it will take to get the film done. If the film calls for actors, you will need to find people who can perform in the way that you want them to, but at the same time, be sure that you are choosing reliable people who will show up on time and stick with the project. In choosing an actor it may be more important to find someone you can work with and whose schedule is flexible than it is to find a trained actor whose availability may be limited. However, it is most important that the actors you choose fit their roles. If the story is about an old man you don't want to use a 25-year-old friend to play the part.

"Scouting" locations is another important part of pre-production. The locations you choose should be visually interesting and should fit the scenes. If the film's central character is wealthy, don't use a dorm room to depict the study in his mansion. Accessibility is crucial in choosing a location. Be sure to obtain the necessary

permission to shoot, not just once, but you should also establish a backup date in case an actor or crew member backs out, the weather is uncooperative, or shooting takes longer than anticipated. Finally, make sure adequate electrical power is available if the shoot involves lighting.

The film might also require specific props and costumes. Again it is important that these items fit the scene. For instance, the wealthy character shouldn't be driving around in a beat up 1989 Honda Civic. Many of the decisions made during pre-production will affect the **production value** of the film. Production value is determined by those elements that contribute to the look of the film and make it more convincing. Locations, sets, costumes, props and actors, as well as technical considerations such as lighting and camera work all contribute to the overall quality and believability of the film's look, or the production value of the film. Coordinating all these elements may seem overwhelming, but with adequate preparation high production value can be achieved without being terribly elaborate.

Scheduling is also a crucial part of pre-production. If the film is large scheduling can be a major job of coordinating the availability of technical crew, actors, locations and equipment. For a small film it can be much simpler, but it is no less important. A **script breakdown** enables a filmmaker to more easily organize a list of locations, actors, props, costumes and any other details necessary for the film. A script breakdown helps in scheduling the shooting of the film in the most logical way. The breakdown makes it easy to see information such as which actors and props are needed at each location and which portions of the script will be shot at each location. The script breakdown can also give the filmmaker an idea of how many days each location will be needed. A simple script breakdown for the film about Justin and Paige might look like this:

Script Breakdown:

Scene	Page	Location	Actors	Costumes/Props	Misc.
1	1,2,3	Justin & Paige's Bedroom	Justin, Paige Scott	Pajamas, Coffee Cups	Cat Wrangler
2	4,5,6	Charlie's Diner	Justin, Paige, Gus, Zoey	Plates with Food	8-10 Extras
3	7	Exterior Dr. Schnitt's Office	Justin, Scott	Justin's Car Justin's Jacket Scott's Leash	Cat Wrangler
4	8	Justin & Paige's Bedroom	Justin, Paige Scott	Suitcase, Clothes Paige's Coat	Cat Wrangler
5	9	Exterior House	Paige	Suitcase, Paige's Coat	Fake Rain

It is a good idea to schedule rehearsal time prior to shooting for narrative films, and it is always important to schedule backup dates for shooting regardless of the type of film you are making. Keep in mind that things usually take longer than expected. Beyond that, there are so many variables involved in making a film that something unpredictable can happen to slow a shoot down or to cause a cancellation. Prepare for the unexpected by making contingency plans ahead of time.

Final Planning

When you visit locations, it is a good idea to sketch a rough floor plan of the space. You can use this to create a **shooting plan** for each location. While the shooting script gives the order of shots as they appear *in the edited film*, the shooting plan arranges the shots in the order that you would actually shoot them. It is almost always faster and more economical to shoot out of sequence. In the example of the scene involving Paige and Justin, you wouldn't light and shoot the medium close-up of Justin (shot 2), move the camera and the lights to shoot Paige's medium shot (shot 3) and then move it all back again to light and shoot Justin's next close-up

(shot 4). Instead, once you've set up a camera position and done the lighting for that set-up, it makes much more sense to shoot all the shots that are called for (in the shooting script or storyboard) from that particular camera angle. By doing this you can capture the seven shots in the shooting script (and in the storyboard) with only four camera set-ups. A shooting plan for the shooting script on page 111 might look like this:

Camera position A, in the corner of the room, captures the establishing shot (shot 1). By changing to a longer lens setting, you can shoot shot 7 (the pan) from the same position. Position B covers shots 2 and 4, the shots of Justin alone. Position C captures the shots of Paige (shots 3 and 5). Camera position D, the close-up of the cat, is put aside out of the shooting plan to indicate that, if necessary, it can be shot anywhere at any time.

Lighting diagrams can also be helpful when planning the details of a shoot. Good lighting diagrams made ahead of time can save time on the day of the shoot and can also assist in planning for the lighting equipment that will be needed. Each camera position defined in the shooting plan is likely to require a separate lighting

diagram. The lighting diagrams simply indicate where, tentatively, the lights should be placed for each camera set-up. Undoubtedly, some changes or fine-tuning will be necessary when actually shooting at the location, but lighting diagrams speed things up by providing a well-considered starting point. A lighting diagram for the camera position that will cover shots 3 and 5 in the bedroom scene might look like this:

A lighting diagram for one camera position from the shooting plan on page 118.

In a scene this simple, it might be hard to see just how economical shooting out of sequence can be. The more complex the film, the more time and effort that can be saved. For instance, if the lighting is very complicated it can take hours to light a shot, and every change in the camera set-up usually requires a change in the lighting. Reducing seven shots to only four set-ups might save several hours. Also, if the shoot will take all day, and the actors are

available for only a few hours each, you can arrange it so that all the shots involving only Justin are shot first, allowing Paige to arrive on the set later. If you then shoot all of the shots involving both characters, you can let Justin go early and finish the day with Paige's close-ups. (Of course, it is preferable to have both actors present for the entire shoot, if possible.)

While the preparations discussed here refer primarily to narrative filmmaking, planning is important for documentaries as well. If you are familiar with the location, you can determine which camera angles will work best and how you might break the space down into various shots. If people will appear in the film, talk to them and let them get comfortable with you before you show up to shoot, since a camera can make people uncomfortable and self-conscious. Be certain that everyone who will appear in the film wants to participate and gives you permission to shoot them.

Finally, when making a film on a limited budget, one way to begin pre-production is to consider the resources available and to utilize them in planning the film. If you happen to have access to an interesting location, consider adapting a scene or an action to fit that location. If a friend has a particular talent, you might find a way to incorporate it into the film.

The purpose of thorough pre-production is to maximize the chances of completing a well-realized film, to avoid wasting the time of the people who are assisting you and to get through the shooting with some shred of sanity. If everything is planned in as much detail as possible before shooting, you won't have to spend so much time worrying that you are missing a necessary shot. Some of the inevitable confusion is avoided, allowing more time for creative thinking on the set.

Chapter 8:
Lighting

It is usually necessary to supplement, modify or invent lighting conditions when photographing a subject on film. In most situations the natural or available light is insufficient in either its quantity or its quality to produce images on film that will create the exposure level and the mood required of a particular scene. Film does not interpret light in the same way the human eye and brain do. For these reasons even beginning filmmakers need to know as much as possible about the characteristics and uses of light.

Light Measurement

Lighting is usually described first in terms of its **intensity**, or brightness. Light intensity can be measured in units known as **footcandles**. One footcandle is defined as the amount of light a so-called "standard candle" would cast upon a subject from one foot away. In any case footcandles are the most widely accepted standard unit of light measurement when measuring the light falling on a subject. The intensity of light on a subject decreases as the subject moves farther from the light source. This **fall-off** in intensity is more pronounced when the subject is close to the light source. If an actor is three feet from the light and moves another foot away, the intensity of the light on the actor will be noticeably diminished at the new distance. If the actor is thirty feet away and moves back another foot, there will be no perceptible change in light intensity.

In order to measure light intensity and choose the correct f-stop for the best exposure, either a reflected or an incident light meter can be used. A filmmaker working in 16mm with a handheld reflected

light meter can avoid potential exposure problems by taking readings from a gray card rather than from the subject. In a complicated lighting set-up or when creating a special lighting effect (such as silhouetting an actor or purposely overexposing a scene) an uninterpreted and unmodified reflected light reading is likely to defeat your purpose. Similarly, a built-in reflected light meter in a super-8 camera can be used in the automatic iris mode, or the iris can be adjusted manually. In the automatic mode the reflected light meter in the super-8 camera will continually adjust the lens iris in reaction to changing light. If you choose to manually override the automatic function of the in-camera metering system you can, with the aid of an 18% gray card, avoid most of the potential problems associated with automatic exposure settings.

Regardless of whether you are using a handheld reflected meter or a reflected meter that is built into a camera and connected to an automatic iris, it is important to learn how to properly take reflected light readings with a gray card in order to create the lighting effects you want. Most filmmakers in most situations prefer incident light meters. An incident light meter is like a reflected light meter with a built-in gray card. While incident meters are a little more convenient to use, a reflected light meter used properly with an 18% gray card is equivalent to using an incident light meter. (To review reflected and incident light metering see Chapter 1, Camera and Lens.)

Quality of Light

Discussions of the **quality** of a light source center on the type of lighting effect it creates. A **hard** light source produces parallel light rays that hit an object from a single angle. When hard light strikes an object it creates hard-edged, well-defined shadows. Sunlight on a clear, cloudless day is an example of hard light. Since hard light creates hard shadows it emphasizes the texture of the objects that it hits. If a person's face is illuminated by a hard light source, every whisker, blemish and scar will cast a

distinct shadow and will tend to stand out. In old westerns heroes like John Wayne and Gary Cooper looked tough and rugged thanks to hard light sources.

Soft light is the result of many rays of light striking the subject from many different angles. Soft light tends to wrap around an object, casting less distinct shadows, de-emphasizing texture and smoothing over blemishes. Sunlight on a cloudy day is a good example of soft light, since the parallel light rays of the sun are diffused (or scattered) by the clouds. Shadows on the ground are indistinct and soft-edged. In Hollywood films actors are often lit with soft light to smooth out blemishes or wrinkles and to make them appear younger and more attractive.

A lighting unit designed as a hard light source can also be used to create soft light. A hard light can be bounced off a white surface and the resulting light will be quite soft. It is common practice to bounce lights from the walls or ceiling of a room. If the walls aren't white or if they are too far away from the subject being lit, a large piece of white foam core (available at most art supply stores) makes a good, portable **bounce card**. Hard lights can also be softened to a lesser extent by placing diffusion material in front of the light. **Diffusion**, a gauze-like, heat-resistant material that is available in a number of styles, scatters rays of light as they pass through it.

Lighting Tools

Lights can have a number of features. Every light has a **socket** in which the **lamp** can be mounted. A bare light bulb at the end of an extension cord might illuminate (or at least seem to illuminate) a scene in a mechanic's garage. That is as basic a lighting unit as there is, but almost all movie lights have a **reflector** in addition to the socket. The scoop-shaped reflector directs the beam of light. The shape of the reflector and its position in relation to the lamp are the main factors that determine the quality of light the source emits. Most lighting units also include **barndoors**, which are useful

in shaping the beam of light. Barndoors are hinged metal flaps that mount in front of the reflector, and they can be partially opened or closed to achieve the appropriate effect. They can be helpful in shielding one area of a shot from light that is intended to illuminate another part of the frame. Some lights include a focusing mechanism, a knob or lever that can move either the reflector or the lamp forward and backward, altering the quality of light as the physical relationship between the reflector and the lamp changes. When the reflector and lamp are close together, they create rays of light that are more nearly parallel, resulting in a hard, narrow "spotlight." When the reflector and lamp are farther apart, the light has more opportunity to bounce from a wider variety of points inside the reflector. The rays of light that are emitted are less parallel, and a slightly softer and broader "floodlight" results.

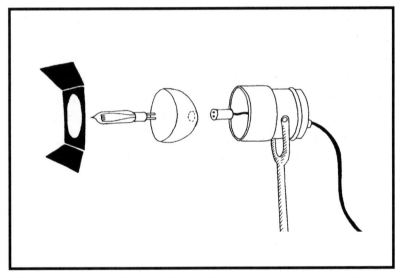

A basic diagram of a light showing the barndoors, lamp, reflector, socket and housing.

Two types of basic lighting instruments are used for most location lighting situations. Standard **incandescent lamps** are designed like conventional household light bulbs. They are easy to handle,

comparatively inexpensive and can be found in almost all camera stores in sizes ranging up to 500 watts. At higher wattage these standard incandescent lamps become very large and cumbersome. **Quartz-halogen lamps** are more efficient than standard incandescents in that they create much more light intensity for their size. They are more difficult to handle and more expensive, but because of their size they allow much greater mobility during shooting.

A standard incandescent light consists of a tungsten **filament** that glows when it is heated, and the filament is surrounded by a standard glass bulb or **envelope**. As the filament burns, the tungsten evaporates and creates black deposits on the inside of the glass envelope. Because of this trait standard incandescent lamps lose intensity and change color slightly as they age.

Quartz-halogen (or simply "quartz") lamps also have a tungsten filament. Their envelope is made of quartz glass, a softer, more porous and much more delicate type of glass. Quartz lamps burn at higher physical temperatures than standard incandescent lamps do, and their porous glass envelope allows heat to escape. The quartz envelope is filled with halogen gas. When the tungsten filament evaporates during use, evaporated tungsten combines with halogen gas and is re-deposited onto the filament, not on the inside of the glass envelope. While this does not stop the lamp from burning out with age, it does allow a quartz-halogen lamp to maintain constant intensity and color throughout its life. The quartz glass envelope of a quartz-halogen lamp is extremely delicate. It should never be touched since the oil from your fingers will weaken the glass, causing the lamp to burn out prematurely or even bubble and explode. Since quartz lamps are very expensive, and exploding hot glass is hazardous, be careful to handle quartz lamps properly.

Frontal lighting

45° lighting

Side lighting

Three-quarter back lighting

Back lighting

Lighting Angles

A light source will create different effects on the subject depending upon the angle of its placement. Vertical lighting angles refer to the height of the light, and horizontal angles refer to the light's position around the subject. In terms of height, lighting from above seems most natural and most pleasing, because in life almost all light comes from overhead.

Lighting from below, on the other hand, looks unnatural. When a person's face is lit from underneath, areas that would normally be in shadow, such as the underside of the chin and the tops of the eye sockets, are illuminated. Shadows fall upward rather than downward. Lighting from below is often used to create an eerie atmosphere or to make a character or setting seem dangerous or unnatural. *Touch of Evil* (1959) Orson Welles' "B-movie" masterpiece, makes good use of lighting from below in depicting unscrupulous characters and dangerous situations.

Since lights are usually positioned somewhere above eye level, the horizontal angle of a light source is often a filmmaker's primary consideration in lighting a scene (see examples on p. 126). Head-on frontal lighting produces a flat, unattractive look, much like snapshots taken with only a flash for illumination. Light that hits the subject from a 45-degree angle produces "classic" modeling. The nose shadow falls to the side and a little below the nose, and the eye sockets are not filled with shadow. Side lighting (at a 90-degree angle to the camera/subject axis) produces a very dramatic image. There is contrast between the light and dark sides of the face, and the face seems to be cut in half by the light. Three-quarter back light makes a subject look mysterious; most of the face is covered in shadow, with light striking the temple or the edge of the cheek. In the same way lighting from almost directly behind can lend a subject mystery and power; the subject is outlined by a halo of light.

Three-Point Lighting

Very few scenes are lit by a single light source. Usually, several lighting units are involved. A common approach to lighting a subject combines three lights, each one serving a specific purpose. Three-point lighting frequently makes use of both hard and soft light sources and always involves a variety of lighting angles and intensities. The **key light** is the primary source of illumination and may be a hard or soft light source depending upon the mood of the scene. It is often placed roughly 45 degrees off the camera/subject axis and above the

subject. This light produces modeling (or a shadow pattern) that helps give the subject a three-dimensional appearance. Since the shadows created by the key light are usually too dark on film, a second light, the **fill light**, is used to illuminate the shadow areas to some degree. The fill light is not as intense as the key light, so the key light shadows are not completely filled in. The fill light is almost always a soft light source so that it doesn't create a distinct second set of shadows. It is normally placed close to the camera/subject axis at eye level or higher. From this position any shadows created by the fill light will be hidden behind the subject from the camera's vantage point.

The third light is the **back light**, placed behind the subject and high enough to be out of the frame. This is often a hard light and it is positioned to create an outline of light around the subject's head and shoulders. Without this outline the subject tends to blend into the background. The back light separates the subject from the background, adding apparent depth to the shot. The subject looks like a three-dimensional person in front of a wall rather than a flat image on the wall.

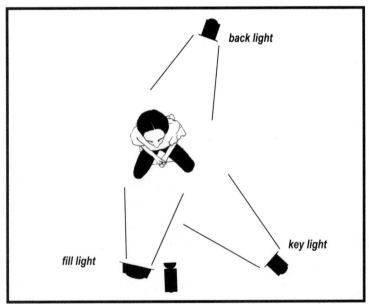

A three-point lighting diagram

In many cases a fourth light source, a **background light**, is used. This light is positioned to illuminate the background but not the subject. It is useful in creating separation and depth between the subject and the background, and it can also help by eliminating unwanted shadows on the background. Sometimes a three-light set-up consists of a key light, a fill light and a background light rather than a back light. The background light separates the subject from the background without the often unmotivated outline of light that a back light creates.

When lighting a shot with two or more actors, a three-point lighting set-up isn't always needed for each actor. Sometimes one fill light can cover the whole shot, with perhaps an individual key light for each character. If two characters are facing each other, **cross-lighting** might be more economical. In cross-lighting two lights are used to create a crossing pattern of light, so that each light acts as one character's back light and the other character's key light at the same time. A single fill light positioned near the camera can fill in the shadows. (See p. 130 for a cross-lighting diagram.)

Motivated Light

When planning any lighting set-up a primary consideration is whether the light is **motivated** or **unmotivated**. Motivated light is rationalized by a source that is either shown or suggested within the scene. If a character is sitting next to a bright window and the side of her face that is closer to the window is brighter than the side that is farther from the window, then the bright light on her face is explained or motivated by the presence of the window, even if the light hitting the actor's face is actually coming from a source used to imitate the window light. In another example, if a room is bathed in red light but no red light source has been established in the room, then this red light is unmotivated. If another shot has established that there is a red neon sign outside the window, then the red light inside the room is motivated. A good example of motivated lighting appears in Atom Egoyan's 1995 film, *Exotica*.

As two characters sit in a parked car during a heavy rain, a moving pattern of dappled light illuminates their faces. This effect is motivated by the streetlights shining through the rain-covered windshield. In this example the lighting accentuates the sad, disturbed state of one of the characters, but it does this subtly because it is motivated by the physical setting.

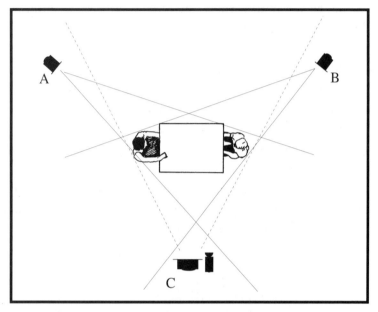

A cross-lighting diagram. Lights A and B each serve as a key light for one character and as a back light for the other, while light C is a fill light for both.

Color

The color of daylight is bluer than that of tungsten light (see Chapter 2, Film Stock). When shooting color film a filmmaker must be careful about mixing daylight and tungsten light sources. If bright daylight coming through a window is used as the key light for a shot of a person, and tungsten-balanced light is used to fill in the shadows, there will be two different colors of light on the subject's face. In most situations this is not a desirable effect, especially when lighting a human face. If the fill light is intended to appear to be just the ambient light in the room, and the scene is

meant to look natural and unlit, then the difference of colors will defeat this aim. Usually either the daylight source (the window) or the tungsten-balanced source must be filtered so that both sources are creating the same color of light.

A **full blue** (or **daylight blue**) **gel** could be placed in front of the tungsten light source. A gel is a sheet of acetate material used to filter light. The tungsten-balanced light passing through the blue gel is converted to the color of the daylight coming through the window. In terms of color it is as if all the light in the scene is daylight. In this situation daylight-balanced film will not require any filtration. If you are shooting tungsten-balanced film, place an orange filter (85 filter) in front of the lens so that all the light that hits the film will be properly filtered to match the tungsten-balanced film. (On a super-8 camera leave the filter in.)

Alternately, you could place an **orange 85 gel** (the same color as the filter built into a super-8 camera) over the window and leave the tungsten-balanced light unfiltered. In that case the daylight passing through the orange gel is converted to match the tungsten-balanced light source in the room and no filtration will be needed on the camera when shooting tungsten-balanced film. Daylight-balanced film would require a blue (80A) filter to convert the tungsten-balanced light to the color balance of the film.

Of course, there are times when mixed light sources can be acceptable and can even be quite beautiful. In a shot in which a character is sitting near a campfire, one side of the character's face might be lit by an orange light motivated by the firelight. The other side of his face might be illuminated by a blue fill light, creating the impression of moonlight.

Sometimes beginning filmmakers are confused by the use of the terms "hot," "warm" and "cool" in discussions of lighting, color and exposure. In a lighting set-up a light that is too bright might be referred to as being too "hot." In the same way an overexposed

shot might be called "hot." When discussing color it is common to call colors at the blue end of the spectrum "cool" and to refer to those at the red end of the spectrum as "warm." These are common slang uses of these terms. Such usage can be confusing, because in scientific discussions of **color temperature** blue light has a higher color temperature than red light.

Color temperature, while related in theory to actual physical temperatures, does not indicate the amount of heat generated by a light source, nor does it measure the burning temperature of a lamp's filament. Instead, the color temperature of a light source indicates the *color quality* of the source. It indicates whether the light source is biased toward the red or blue part of the spectrum, or somewhere in between.

Color temperature is measured in degrees Kelvin (°K). The two important color temperatures to remember are the color temperature of tungsten-balanced movie lights (3200°K) and that of daylight (5500°K). A color temperature of 3200° Kelvin indicates a light source that is orange in its color quality. 5500°K indicates a bluish light. Different kinds of light sources produce various colors of light, even though most people don't usually notice the differences. The human brain has the ability to adapt to situations that are not too extreme, making the light from most sources appear as neutral white light without a strong bias. But film stocks cannot adapt in that way. A color film stock must be manufactured to reproduce color correctly under one specific type of light. 3200°K was established as the standard color temperature for tungsten light, and now all professional tungsten-balanced color film stocks are manufactured to reproduce color properly when exposed under light of that color temperature. Tungsten-balanced color film will reproduce colors correctly when it is used in combination with tungsten-balanced movie lights. Some color films are daylight balanced. They are manufactured to be exposed under light with a color temperature of 5500°K. Kodak currently makes several daylight-balanced 16mm film stocks. There are no daylight

balanced super-8 film stocks. (Note: Kodak does not classify super-8 film as professional film, and tungsten-balanced Kodachrome film is actually balanced for 3400°K. The difference between 3200°K and 3400°K is just barely noticeable. Most of the time it can be ignored. If you want to be absolutely correct you can buy tungsten "photoflood" light bulbs that are balanced for 3400°K. They are available in many camera stores.)

What happens when film is exposed under light of the wrong color temperature? Tungsten-balanced film exposed in the relatively blue light of daylight will look blue unless an orange 85 filter is used to correct the daylight, converting its color temperature from 5500°K to the color temperature for which the film is balanced, 3200°K. Orange 85 filters are built into the optical system of all super-8 cameras. Built-in filters are rarely found in 16mm cameras, so it is necessary to put a glass filter on the front of the lens. If the camera has a filter slot behind the lens, a gelatin filter can be used in the slot. The 85 filter is put in place when shooting tungsten-balanced color film in daylight, and it is removed when shooting under movie lights. Daylight-balanced color film would look orange if exposed under tungsten-balanced lights without any color-correcting filtration. A blue 80A filter is used to convert 3200°K light to 5500°K, the daylight color temperature (see Chapter 2, Film Stock). Black-and-white films are not affected by color temperature in any significant way, and they can always be exposed in either daylight or tungsten light without any filtration.

Lighting Contrast

In any lighting set-up it is important to control the **lighting contrast ratio**. This is a measure of the difference in light intensity between the brighter and darker sides of a subject. These areas can be referred to as the **highlight** and **shadow** areas. Since the highlight area will usually be lit by both the key light and the fill light, and the shadow will only be lit by the fill light, the lighting contrast ratio can be expressed as the ratio *key + fill : fill*. Using the light on an actor's

face as an example, if the highlight side of the face (the key light plus the fill light) is twice as bright as the shadow side of the face (the fill light alone), then the lighting contrast ratio is 2:1.

Lighting contrast ratios can be easily measured using an incident light meter. First, take a reading by holding the meter in front of the subject so that it is hit by both the key light and the fill light (the highlight). Take a second reading holding the meter so that it is hit by the fill light alone (the shadow area). If the highlight area of the subject is illuminated by 200 footcandles and the shadow area by 100 footcandles of light, the ratio is 2:1. If the highlight reads 1,000 footcandles and the shadow 100 footcandles, the ratio is 10:1. While it requires a little more effort to measure a contrast ratio using a reflected light meter, it can be done effectively by taking two reflected light readings from an 18% gray card. First, hold the gray card in front of the actor's face so that the light from both the key light and the fill light hits the card and fully illuminates it. Suppose the light meter reads f/4 in this case. Take a second reading with the gray card positioned so that only the fill light falls on it. To do this shade the card so that your body blocks the key light, or simply turn the key light off. Suppose the light meter reads f/2.8 now. The bright side of the face is one stop brighter than the darker side. A one f-stop difference in the two light readings means that the highlight is twice as bright as the shadow (see "Exposure" in Chapter 1, Camera and Lens), so the lighting contrast ratio is 2:1. Moving the key light closer to the subject or using a brighter light might result in readings of f/5.6 in the highlight area and f/2.8 in the shadow area. (Notice that the intensity of the fill light doesn't change even though the key light is brighter.) Now the difference is two stops, a 4:1 ratio. (As the lens is opened from f/5.6 to f/4 to f/2.8, the size of the lens iris is doubled and doubled again.) A three stop difference indicates an 8:1 ratio; a four stop difference indicates a 16:1 ratio and so on.

You can use this method of measuring lighting contrast ratios in other situations. If you are shooting outside and have one actor standing in the sun and another in the shade, you would take one

2:1 lighting contrast ratio

4:1 lighting contrast ratio

8:1 lighting contrast ratio

16:1 lighting contrast ratio

The same subject shot with different lighting contrast ratios.

light reading in the sunny area and another in the shaded area. Often the resulting ratio will be unacceptably high, and you won't be able to do anything to reduce it. You have to decide which is more important in the scene, the highlight area or the shadow area, and choose an f-stop accordingly. Usually, you will want to expose the film properly for the most important part of the composition. Sometimes, in high contrast situations, it is useful to shift the exposure slightly in order to preserve some detail in other areas of the frame.

Different lighting contrast ratios suggest different moods on film. Traditionally, higher ratios are used for more dramatic scenes, while low ratios are typically used for less serious moments. Knowing

the lighting contrast ratio in a scene helps a filmmaker to visualize how the light will look on film, which is usually very different from the way it appears to the eye.

Contrast ratios are especially important when working with reversal film because of its limited latitude (see Chapter 2, Film Stock). Reversal film has a very limited tolerance for overexposure and underexposure. If the shadow areas in the frame are underexposed by more than three stops they will start to lose detail, and the shadows will be rendered as undifferentiated black. If the highlights are overexposed by more than one stop they will begin to burn out. If the contrast ratio is higher than 16:1 (a four stop difference) no matter which intermediate f-stop you choose for exposing the film, you cannot avoid either overexposing the highlights or underexposing the shadows to the point that substantial detail is lost. In this case it is necessary to add fill light to bring the lighting contrast ratio down to an acceptable level. Negative film has a much wider latitude. Shadow areas can be underexposed by two or three stops without losing detail, while highlights can be overexposed by three or four stops without completely burning out.

Night Shooting

Some situations call for a special exposure. When shooting a night scene there is almost never enough available light to expose the film. Street lights or moonlight, even though they create enough light for human vision, have practically no effect on most film stocks. The most convincing way to shoot an outdoor night scene is to shoot **night-for-night**. This means shooting in the dark and using lighting units to selectively illuminate and highlight the scene. It isn't necessary or even desirable to fully illuminate everything since the idea is to make it look like night, but night-for-night shooting can still be cumbersome. If the shot is a long shot or an extreme long shot, it might require many powerful lighting units to light it. In most productions that translates to a great deal of time and expense. So, in some cases filmmakers choose to shoot **day-for-night**.

Day-for-night shooting involves shooting a night scene on a bright sunny day. Usually, this is done by underexposing the film and shooting late in the afternoon or early in the morning when the shadows are long. It is also necessary to avoid showing any sky in the shots, as it is too bright and destroys the illusion. Some filmmakers put a blue filter over the lens to make the film look a little bluish, since it is an old filmmaking convention that moonlight is blue. Day-for-night shots are usually underexposed by one or two stops. The position of the sun in relation to the subject is important. The sunlight should hit the subject from the side or even from behind. The sunlight outlines the subject but much of it is left in the dark, underexposed shadows. Day-for-night shots won't work if the day is overcast. They require hard sunlight. Unfortunately, day-for-night scenes frequently look very artificial. In 16mm and 35mm productions the film laboratory can improve the look of day-for-night scenes by making timing adjustments when they are printed, but often it is still an unconvincing effect. It is a particularly difficult effect to pull off in super-8 due to the limitations of the available film stocks. Since few super-8 productions are printed (most super-8 filmmakers end up showing the camera original, not a print), laboratory color and exposure correction is usually not a practical option. A day-for-night scene will probably look more believable if it is shot in black-and-white rather than in color. Of course, when shooting in black-and-white there is no need to use a blue filter.

Another alternative is to shoot **dusk-for-night**. Dusk-for-night involves shooting in that very short period of time after the sun goes down, when street lights and business signs and car headlights are on, but while the sky is still bright and there is enough light to expose the film. Again, all shots must avoid showing the bright sky. The first few shots might be intentionally underexposed, but very soon there will be barely enough light for shooting, and then not enough. Since there will be about half an hour of usable light in the summer and even less in the winter, shooting must be done quickly and efficiently. Since they require fast shooting, dusk-for-night sequences have to be well planned ahead of time.

While day-for-night and dusk-for-night techniques are frequently used in low budget productions, keep in mind that these productions are almost always shot on 35mm or 16mm negative film which have much greater exposure latitude than does reversal film, regardless of whether it is 16mm or super-8. When attempting these techniques, shoot detailed test footage ahead of the shooting date to avoid wasting time and money. It is important to test variables like exposure, the time of day and the camera angle in relation to the angle of the sunlight. In day-for-night shooting a good starting point for exposure might be about one and one-half stops underexposed. If you are shooting 16mm negative film, contact your film laboratory's timing department and ask for their recommendation regarding exposure and filtration.

Shooting Titles

One of the simplest ways to make a film seem more finished is to create titles and credits for the beginning and end of the film. These might include the title of the film, your name (for instance, "a film by Frank Booth") the names of actors, crew members or anyone else who made important contributions to the project. The simplest titles to make are hand lettered on white or colored paper. Titles made this way often look about as cheap as they are to make. If sloppily made or badly lit they can reflect badly on the film. Printed titles usually look better and can be made in a number of ways, ranging from a laser printer to rub-on lettering.

Many films use titles that are white letters on a black background. The best way to make these titles involves printing black letters on white paper. This artwork is taken to a printing shop where a **sheet negative**, or **Kodalith**, is made. The sheet negative is a high contrast black-and-white negative image of the original artwork, a large sheet of negative film on which the background is opaque black and the letters are transparent. "Kodalith" is the name of Kodak's brand so sheet negative, but is so commonly used that the name has become synonymous with any sheet negative. To shoot these

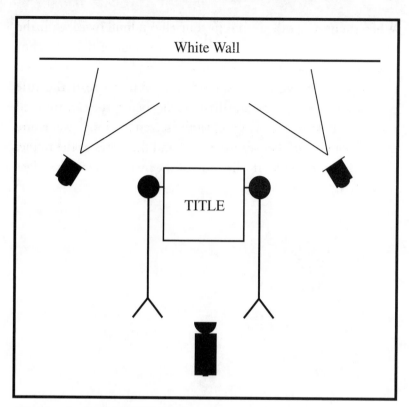

Set-up for shooting backlit Kodalith titles.

titles hang the sheet negative a few feet in front of a white wall. You can hang the sheet negative by stretching it between two light stands and taping it to both of them. Using one light on either side and at 45 degrees to the wall, light the wall behind the sheet negative. Make sure the wall is lit evenly and that none of the light spills onto the front of the sheet. Usually, placing a sheet of diffusion material over each light helps to make the light on the wall more even. Take either an incident light reading at the wall or a reflected reading using a gray card placed against the wall behind the sheet negative. Whatever f-stop the meter indicates, set the lens iris to that f-stop. Put the camera on a tripod about five feet beyond the hanging sheet negative, and frame and focus it on the sheet negative. Remember to focus on the sheet, not the wall.

When shooting a title, read it to yourself out loud twice while the camera is running. You will probably cut it shorter than this, but it is better to shoot too much rather than too little. When the film is projected the audience should have time to read the title comfortably without the title disappearing before they are finished reading and without it hanging on the screen too long. Make sure there is some space between the titles and the edges of the frame, since projectors mask off a little bit of the image around the edges of the frame.

Chapter 9:
Sound

Film is primarily a visual medium and filmmakers are encouraged to think visually. However, even the earliest "silent" films usually included some kind of aural accompaniment, or **soundtrack**, to enhance the visual content of the film. At first musicians performed this accompaniment. Later, technical advances made it possible to mechanically record sound to be played back in synchronization with the images on the film (**sync sound**). 16mm production offers quite a bit of control and many creative options in the creation of a soundtrack. The super-8 format poses significant sound limitations, but working within those limitations, it is possible to do fine work. A well-made soundtrack can enhance a film, but sloppy sound can detract from even the most visually beautiful film.

Characteristics of Sound

Sound can be thought of as a disturbance in the air, like the disturbance created in water when a rock is thrown into a pond. When an object like a guitar string vibrates quickly, waves of sound travel through the air like ripples traveling through water. As the string moves in one direction it pushes the air in that direction, causing a wave of increased air pressure. When the string pulls back it creates a trough of lower air pressure. As this action is repeated many times each second, a series of pressure waves are formed which move through the air. When they reach the ear they cause the eardrum to vibrate back and forth with the changes in air pressure. A series of bones and nerves are connected to the eardrum, and they convert this pattern of air pressure changes into a pattern of electrical impulses that travel to the brain.

The Sine Wave

These waves of air pressure can be diagrammed into a regularly repeating pattern called a sine wave. This diagram can be used to describe the characteristics of the sound itself. The height of the wave indicates the sound's volume or **amplitude**. The greater the amplitude the louder the sound seems to be. Amplitude is measured in **decibels** (**dB**). The decibel scale is relative rather than linear. An increase of 10dB means a doubling of the amplitude; a 10dB sound is about twice as loud as a 0dB sound and a 30dB sound is about four times as loud as a 10dB sound. 0dB is considered the "threshold of hearing." Any sound softer than 0dB does not deflect the eardrum enough to register as a sound. Approximately 130dB is considered the "threshold of pain." Sounds louder than 130dB begin to overload the auditory system and can damage the ear. The **dynamic range** of a sound receiving device is the range from the softest sound it can register to the loudest sound it can handle. Therefore, the dynamic range of the human ear is about 130dB. The dynamic range of a sound producer is the range from the softest to the loudest sound produced. The dynamic range of a summer storm might vary from the rustle of the wind in the trees to a loud clap of thunder directly overhead.

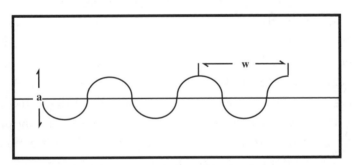

A sine wave diagram showing amplitude (a) and wavelength (w).

Measuring the distance one cycle of a sine wave covers, from crest to crest or trough to trough, is a measure of the **wavelength**. Large objects, like a cello string, vibrate slowly and produce sound with

a long wavelength. Small objects, like a violin string, vibrate more quickly, resulting in sound with a shorter wavelength. The longer the wavelength, the fewer sound wave cycles strike the ear in a given amount of time. Therefore, a sound with a longer wavelength is said to have a lower **frequency**. Frequency is measured in "cycles per second," commonly referred to as **Hertz (Hz)**. Lower frequency sounds are often called **bass**, while higher frequency sounds are known as **treble**. Any sound with a frequency lower than approximately 20Hz is felt as an actual vibration rather than being heard as a sound. A sound with a frequency higher than 20,000Hz does not register on the human eardrum enough to register as a sound, but animals such as dogs and bats can hear sounds at these high frequencies. The approximate **frequency range** of the human ear is from 20Hz to 20,000Hz.

Microphones

Sound can be collected, recorded, stored and reproduced by an electronic audio system that mimics human hearing in certain ways. A **microphone** is the part of an audio system that captures sound. The microphone contains a wafer-thin diaphragm that vibrates back and forth like the human eardrum does when sound waves hit it. In a **dynamic** microphone a metal pin is attached to the diaphragm and a coil of wire is attached to the metal pin. The vibration of the diaphragm causes the coil of wire to move back and forth within a magnetic field. This movement causes changes in the voltage signal which travels from the microphone through a cable to a recording device.

A simple microphone

In a dynamic microphone these voltage signals are very weak. Soft sounds that deflect the diaphragm only slightly may create a signal so weak that it cannot be transmitted from the microphone. Dynamic microphones are frequently described as being self powered, relying only on the actual air pressure of the sound to create a signal. A **condenser** microphone uses a power source, either an alkaline battery inside the microphone or a separate power supply, to amplify the voltage signal, allowing even soft sounds to be recorded. Condenser microphones are best suited to situations in which the sound is soft. They are also useful when the sound is coming from far away, since sound dissipates with distance. For this reason condenser mics are commonly used during sync sound shooting, since the microphone must usually be placed some distance from the action.

Pick-up Patterns

Even though sound dissipates, becoming softer as it travels through the air, distance is not the only factor that determines how well a sound is picked up by a microphone. If it were, then a person speaking ten feet in front of a microphone would register just as clearly as a person speaking ten feet behind it, beside it or anywhere on the perimeter of a circle ten feet from the microphone. Certain microphones do work in this way; they are referred to as **omnidirectional** microphones. They receive sound equally well from all directions and a diagram of the microphone's **pick-up pattern** is depicted as a circle, either drawn on the microphone itself or in an accompanying manual.

In most film work an omnidirectional pick-up pattern is not useful. While a sound recordist usually wants to clearly record the voice of an actor in front of the microphone, there are usually sounds coming from behind the microphone such as the sound of the camera running, which are undesirable and should not be recorded. In such a situation the recordist would choose a *directional* microphone that does not register sounds coming from behind the mic as distinctly as those sounds coming from the front or the

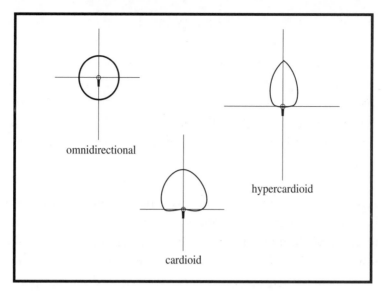

omnidirectional

hypercardioid

cardioid

Pick-up patterns of an omnidirectional, a cardioid and a hypercardioid microphone.

sides of the microphone. Because the pick-up pattern of this type of microphone is roughly heart shaped, it is called a **cardioid** microphone. A microphone with a narrower pick-up pattern that does not register sounds coming from the sides as clearly as those sounds coming from the front is called a **hypercardioid** or **supercardioid**. These microphones, with their extremely narrow pick-up patterns, are commonly referred to as **shotgun** microphones. When recording an actor with a shotgun microphone it is important to aim the microphone directly at the actor's mouth. If the microphone is positioned *off-axis*, the actor's voice will sound muffled in the recording.

While microphones are sometimes handheld, they are usually mounted on a **boom**, a long pole that allows the microphone to be held outside the frame and maneuvered above an actor. However, in some situations a **lavaliere** microphone is used. Lavalieres are extremely small. In some cases lavaliere microphones are no larger than a pencil eraser. They are almost always condenser microphones, and they frequently have an omnidirectional pick-

up pattern. The lavaliere microphone is fastened to an actor's clothes, usually the shirt, and the mic and cable are hidden beneath the clothing. A lavaliere microphone is useful when even a long boom cannot get a microphone close enough to the actor to record dialogue clearly. A *wireless* lavaliere mic allows an actor to be photographed in long shots while their dialogue is recorded. A lavaliere microphone can also be hidden on a set more easily than a larger microphone.

It is important to remember that even though a microphone works like the human ear does in some ways, it does not have the ability to selectively hear or concentrate on certain sounds while excluding others. A microphone's selectivity is limited to the directional qualities of its pick-up pattern, but sounds outside a microphone's pick-up pattern are not completely inaudible; they are simply received and transmitted with less clarity and at a lower level.

Magnetic Tape Recorders

In audio systems the voltage signal created in the microphone travels to a **tape recorder** which encodes a corresponding pattern of electromagnetic changes onto **magnetic tape**. The tape stores this pattern so that it can be reproduced at another time. Magnetic tape consists of a flexible base coated with particles of ferrous **oxide**, which is sensitive to magnetic fields, just as the emulsion of film is sensitive to light. Audiotape is often packaged in cassettes that snap into a cassette recorder like a super-8 film cartridge snaps into a camera. Tape is also sold on reels that must be manually threaded through a "reel-to-reel" recorder in much the same way that 16mm film is threaded through a camera.

When the electronic signals from a microphone reach the **record head** of a recorder, they cause voltage fluctuations in the field of a magnetic coil in the head. As the tape passes over the record head this changing magnetic field creates a specific pattern of magnetism in the tape's oxide particles. When the tape passes

over a **playback head**, the head reads the magnetic pattern of the particles and converts it into a series of varying voltages that can be amplified and sent to a speaker. The voltage signals cause paper cones to vibrate in the speaker, and the vibration of the cones reproduces the range of frequencies and amplitudes of the original sound with more or less accuracy, depending upon the quality of the audio system. In analog recorders, the amplitude and frequency information of the voltage signal is a direct translation of the amplitude and frequency information of the sound. Changing the voltage signal changes the sound quality. This can be an intentional change, for instance increasing the amplitude of the voltage to make the sound louder, or it can be unintentional. For instance, imperfections in the tape or variations in tape speed can affect the voltage signal and cause distortions in the sound.

It is simpler to lay down a magnetic pattern on a blank tape than it is to use a tape with a previous pattern encoded on it, since the old magnetic pattern must be changed at the same time that the new one is recorded. For this reason recorders use an **erase head**

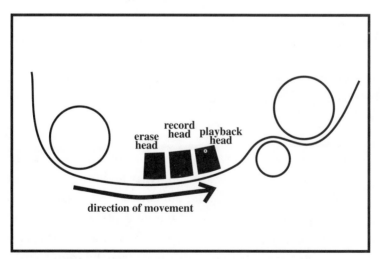

A three-headed recorder showing erase, record and playback heads. Some recorders contain a combined record/playback head, making them two-headed rather than three-headed machines.

that produces a constant magnetic field. The tape crosses the erase head before it reaches the record head. When the record head is recording, any previously recorded signal is destroyed by the erase head first, and the oxide is prepared to receive new information.

Single-System Sound

During **single-system sound** shooting, sound and image are recorded on the same strip of material (the film) in the same machine (the camera) at the same time. Although single-system sound was once used in both the 16mm and super-8 formats, it has been obsolete for some time. Single-system sound is commonly used in many digital and tape-based formats, and it can make sense when shooting in a format that is not going to be edited by physical cutting. This was the major problem associated with editing single-system films.

Film moves through a camera gate in an intermittent movement (see Chapter 1, Camera and Lens), but magnetic tape must move across a record head at a constant rate. Intermittent movement across the record head would result in badly distorted sound. Because of this the record head in a single-system film camera could not be positioned in or near the camera gate. It had to be located in a part of the camera in which the film traveled at a constant rate. Consequently the image was captured at a different place on the strand of film than its corresponding sound. There was a gap between sound and image.

Problems arose when making a physical edit, since both the image and the sound were cut in the same place, even though the image and sound on any given frame did not correspond to each other. On the other hand, videotape and digital capture formats that use single-system technology are quite viable, because they are edited by dubbing or otherwise copying images and sounds from the original capture material to another strand of tape or to a digital file format.

Double-System Sound

Sync-sound films are shot using **double-system sound**. The sound is recorded and the image is photographed simultaneously, but they are on separate strands of material. The sound is recorded on magnetic tape or on one of the digital audio formats in a recorder that is separate from the camera, while the image is photographed onto the film. In double-system shooting the camera and recorder must run in synchronization; if they drift out of synchronization by even one frame the viewer will notice that the sound does not properly match the image. Synchronization can be achieved by linking the camera and a magnetic tape recorder, with a cable. In **cable sync** the camera generates a pulse that travels through the cable to a **sync head** in the recorder. The **sync pulse** is laid down on the tape on a channel that is separate from the audio channel. Because the number of sync pulses laid down on the tape are in direct proportion to the number of frames that move through the camera, the sync pulse becomes an effective reference for putting picture and sound in sync. Later, the sound on the magnetic tape will be re-recorded or transferred onto **magnetic fullcoat**. Fullcoat is essentially thick sprocketed magnetic tape with dimensions that match those of the film format (super-8, 16mm or 35mm). During the sound transfer the sync pulse on the sync channel is used as a reference to precisely control the playback speed of the tape, ensuring that for every frame of picture there will be one corresponding frame of audio on magnetic fullcoat. Since the width and sprocketing of the fullcoat are identical to those of the film, the two strands can be easily synchronized for editing.

Shooting cable sync places limitations on the mobility of both the camera and the tape recorder, because they are physically linked by the sync cable. **Crystal sync** uses quartz crystal technology rather than a cable to assure synchronization. The camera and recorder are not physically joined. A crystal in the camera precisely controls the speed of the camera motor and, therefore, its per-second frame rate. It ensures that the camera runs at *exactly* 24 fps. A separate crystal in the magnetic tape recorder generates an equally precise

sync pulse. The crystal in the recorder does not control the running speed of the machine, but it does generate a pre-determined number of sync pulses that are *exact* in relation to time (60 pulses for every second of real time). Because the crystal in the camera and the crystal in the recorder both function with the utmost accuracy in relation to real time, during the transfer to magnetic fullcoat the sync pulses on the tape will serve as a reference, ensuring a frame-to-frame correspondence between picture and sound. The audio corresponding to 60 pulses on the tape will be transferred onto 24 frames on magnetic fullcoat. When double-system material is edited, the picture and the magnetic fullcoat can be cut separately but in exact relation to each other.

Most films combine sync-sound dialogue with **post-dubbed** music and **sound effects**. Post-dubbed sound is recorded after the film has been shot, during the editing process. While precise synchronization such as that required when trying to post-dub extensive dialogue is problematic, some films are entirely post-dubbed due to budgetary and aesthetic considerations. Post-dubbed films usually utilize some combination of music, sound effects (such as footsteps or a telephone ringing) and **voice-over** narration in which one of the film's characters or a narrator speaks on the soundtrack but does not appear on the screen.

Sound Editing and Mixing on Film

In making a 16mm film, the various sounds (sync dialogue, music, sound effects and voice-over) are usually transferred from the audiotape to 16mm magnetic fullcoat. Individual sounds are cut into separate rolls or tracks with silent filler material (known as "sound fill" or "slug") used to space out each track so that the sounds are placed to match up with the corresponding images. Many sounds can be cut into one track, but sync dialogue, music, voice-over and sound effects are usually segregated into individual tracks. A feature-length film might have dozens of edited tracks, but short, low-budget productions might have as few as three or four.

When the tracks are completed, they are mixed together in a sound studio. During the **sound mix** the edited tracks are re-recorded together onto a single, uncut roll of fullcoat. The levels of individual tracks can be raised or lowered in relation to the other tracks, while the character of each individual sound can also be controlled and enhanced to create a rich, multi-layered soundtrack that complements the image. Normally the edited workprint is projected, either on a screen or a video monitor, during the sound mix. The picture is in sync with the tracks and is a valuable visual reference.

Digital Audio Recording

Audio recording and manipulation have benefited tremendously in recent years from the development of digital technology. Digital audio has two major advantages over analog audio. There is no loss of quality from one copy, or **generation**, to the next as long as the audio remains in the same digital format. The second benefit is the ease with which sound can be synchronized to picture.

Analog methods of sound recording recreate sound waves as a continuous electrical or magnetic signal that is a close duplicate of the original sound. This signal is susceptible to distortion, noise and a degradation of quality each time it is copied. A digital sound device records the sound wave as a series of numbers. These digital recordings are not subject to distortion, noise or generational loss when they are duplicated, because the series of numbers remains the same from one generation to the next.

Digital audio recordings are made using a process called **sampling**. Sampling works by taking readings, or samples, of a sound wave many times per second and assigning a number value to the amplitude and frequency information of the sound at each particular instant. Two factors control the quality of the sampled sound: the **sample rate** and the **bit rate**. The sample rate indicates how many times per second the sound is sampled and is measured in **kilohertz (kHz)**, or thousands of cycles per second. Higher

sample rates produce better quality sound since more samples result in more pieces of information, more accurately reproducing the sound wave. The bit rate is the size of the range of possible number values used to record each sample. Higher bit rates result in a larger range of possible values, and a larger range of possible values means a more precise representation of the sound wave. 8-bit sound has only 256 possible values. 16-bit sound has 65536 possible values and will create a much more detailed representation of the sound wave. A variety of sample rates and bit rates are in use at this time.

The digital audio format currently used by most professional film sound recordists is **Digital Audio Tape (DAT)**. DAT recorders typically use a sample rate of 48kHz or 44.1kHz and a bit rate of 16 or 24 bits. Many DAT recorders can record SMPTE time code along with the audio signal. This allows them to run in precise synchronization with videotape recorders and with other devices that use SMPTE time code. Audio with SMPTE time code can also be easily synchronized with film that has been transferred to videotape.

A newer digital audio format, aimed initially at the consumer market, is Digital **MiniDisc**. MiniDisc uses a small disc, roughly the size of a computer floppy disk, and records with a sample rate of 44.1kHz and a bit rate of 16 bits. MiniDisc recorders also use a small amount of compression in making recordings (see Chapter 6, Digital Editing for a discussion of compression). This compression is slightly evident in music recordings but has a negligible effect on voice recordings. MiniDisc recorders are usually less expensive than DAT recorders.

Digital audio recorders function in much the same way as analog recorders and they have similar controls. MiniDisc recorders, because they can access specific points on the recording disc randomly and quickly, also have the added feature of being able to jump to parts of recorded material that the user has marked electronically. A digital recorder also offers a powerful feature for recording sync sound.

Because its sampling rate is controlled by a precise quartz crystal, its speed is absolutely consistent. Playback speed will always be exactly the same as the original recording speed. This assures that sound will be in sync with picture, provided that a crystal sync camera was used.

Since microphones produce analog signals, these signals must be converted into digital signals in order to make digital recordings. This is done in a part of the digital audio recorder called an **analog-to-digital converter (A-D converter)**. High quality A-D converters typically have high bit rates so that the sound can be recreated with very little degradation. Amplifiers and loudspeakers are also analog devices. Playing back from a digital audio device into an amplifier requires a conversion of the digital audio into an analog signal. This is done in the digital recorder's **digital-to-analog converter (D-A converter)**.

Once a digital recording has been made, it can be copied many times without loss of quality, as long as it is not converted from digital to analog. Converting a digital audio signal into analog form and then recording it with another digital device will result in a loss of quality. Quality will also be lost if the audio signal remains in digital form but the sample rate or the bit rate are changed. If the audio is going to be taken through multiple generations, it is important that it remain in the same digital format at all times. For instance, digital audio signals can be transferred from a digital audio recorder to a computerized editing system with no loss of quality as long as the two devices have the same type of connection for digital information input and output. The sample rate and bit rate of the editing system must also match those of the original digital recording.

Digital Sound Editing and Mixing

Today much of the work of sound editing and mixing is done digitally. Many computer editing systems have very sophisticated audio editing capabilities. The editor can create multiple

soundtracks and can edit them much more precisely than when working with magnetic fullcoat. "Undo" and "redo" functions allow edits to be changed many times without damaging the audio signal, and sound effects and lines of dialogue can be reused many times without any loss of quality.

Advanced audio manipulation usually requires the use of a **digital audio workstation** (**DAW**), a computer with powerful software dedicated to changing the characteristics of audio signals. DAWs allow the sound editor to easily perform a wide range of operations such as speeding up or slowing down sounds or changing a line of dialogue to make it sound as though it is being spoken in a large room or over a telephone line. Once the sound editing is finished, the soundtracks can be mixed on the DAW. Most DAWs allow the sound level changes in a mix to be rehearsed by the sound mixer and then performed automatically by the machine, removing the possibility of human error in the final mix.

Finally, in order to end up with an answer print on film, the digital audio from the computer editing system or the DAW has to be synced to the camera original footage in some way. If you are working with video dailies that were made with SMPTE time code on the videotape, using keycode information from the edge of the camera original footage, this can be a fairly straightforward process. The final picture Edit Decision List (EDL) is output from the computerized editing system, enabling the filmmaker to cut the camera original footage based on the film's latent edge numbers. The mixed digital audio must be output onto a suitable audio format that the film laboratory can work with to make the answer print. Outputting onto magnetic fullcoat is one option that makes the matching of audio and picture and a final check of sync relatively easy. In this case the audio must be sped up by 0.1% during output, since the picture and any associated sync dialogue were slowed down by that amount when the material was transferred to videotape. All the other tracks have also been edited in relation to that slightly slowed down version of the picture.

If your sountracks have been built and edited on magnetic fullcoat, they can still be mixed digitally. In order to do this each track is digitized into the DAW while it is being played back from a high-quality magnetic fullcoat machine (or a group of machines that are locked together). Each track must have a clearly audible sync mark at its head and at its tail. Once all of the tracks have been digitized, these audible sync marks can be used to line the tracks up in relation to each other on the DAW's timeline. All of the advantages of digital mixing are now available. The final mixed soundtrack can be output to magnetic fullcoat without being sped up (since the audio was never transferred to videotape and, consequently, was never slowed down). This final mix on fullcoat should be checked against the edited workprint before the materials are sent to the film laboratory.

Before the film laboratory makes an answer print the mixed magnetic soundtrack is converted to an **optical track**. In the optical track the magnetic pattern of sounds on fullcoat becomes a pattern of dark lines on clear motion picture film. The optical track is printed onto the edge of the answer print. During projection, as light is shone through the optical track, this pattern of dark lines will dictate the voltage pattern sent to the speaker. The optical sound reader in a 16mm (or 35mm) projector will read the optical track from the edge of the print. When working in double-system sound this is the first time that sound and image are together on the same piece of material. The film can now be screened.

Glossary

A-D converter: an **analog-to-digital converter.**

Amplitude: the volume or loudness of a sound.

Analog-to-digital converter: converts information into a series of numbers for use in a digital audio device or a computer; **A-D converter.**

Animation: creating the illusion of motion where none exists by shooting objects or a sequence of drawings frame by frame with slight changes between frames.

Answer print: the first complete, finished print of a film, usually with sound.

Aperture: 1) in the camera, the opening cut into the **aperture plate** which defines the edges of the frame. 2) in the lens, the **iris.**

Aperture plate: a metal plate in the camera between the film and the lens. A frame sized cut-out in the plate allows light to strike the film.

ASA: American Standards Association; the scale which assigns a numerical rating to the **speed,** or sensitivity, of a film stock. ASA is interchangeable with **EI** and **ISO.**

Aspect ratio: the dimensions of the frame in a given **format,** described as a numerical ratio of the frame's width to its height. 16mm, 8mm and super-8 film all use an aspect ratio of 1.33:1.

Assembly: initial splicing together of selected shots; the first step in the editing process.

Background light: a light that illuminates the background behind the subject.

Back light: light that hits a subject from behind. It doesn't usually serve as a significant source of illumination. Rather, its purpose is to outline the subject and separate it from its background.

Barndoors: hinged metal flaps that mount on the front of a light and which shape the light coming from the lighting unit

Barrel: of the lens; the tube that connects and holds the lens elements in place.

Base: the flexible strip of **cellulose triacetate** material that the **emulsion** is coated onto.

Bass: low-frequency sound.

Bin: in a computerized editing system, a computer folder containing **clips**.

Bit rate: the size of the range of possible number values used to record each **sample** in a digital audio recording; the higher the bit rate the greater the accuracy of the audio reproduction.

Black-and-white: a film stock that does not differentiate between colors; everything is reproduced in varying shades of gray from black to white.

Blocking: the choreographing of all movement in a shot, both subject movement within the frame and camera movement.

Blow-up: the process of rephotographing one film **format** onto another, larger film format.

Boom: a pole used to hold a microphone so that it is as close as possible to the sound being recorded.

Bounce card: a large sheet of reflective material used to soften and direct light toward a subject.

Cable sync: a method of synchronizing sound and image in double-system shooting. The camera and recorder are linked by a cable.

Camera gate: the area inside the camera in which the film is exposed to light.

Camera original: the film stock that has actually run through the camera. It can be **negative** or **reversal**.

Camera speed: same as **frame rate**.

Camera take: during shooting, a shot; the strip of film that is exposed from camera start to camera stop; also simply called a **take**.

Cardioid microphone: a microphone which picks up sounds coming from its front and sides more clearly than it picks up sounds coming from behind.

Cellulose triacetate: the material that the film **base** is made of.

Changing bag: a portable light-tight bag that is used for loading film stock into a camera (a portable "darkroom").

Changing tent: like a **changing bag** but supported by a rigid frame for ease of use.

Clip: in a computerized editing system a **digital media file** representing a specific piece of picture or sound.

Close-up: when of a person, usually a shot of the head and shoulders.

Color temperature: a measure in degrees Kelvin (°K) of the color quality of a light source. Lower color temperatures indicate the red/orange part of the spectrum, while higher color temperatures tend toward blue.

Compression: reduction of size and quality of digitized files in order to conserve space on a computer's hard drive.

Condenser microphone: a microphone that uses a power source to boost or amplify the audio signal.

Conforming: the process of editing the **camera original** to match the edited **workprint** frame for frame.

Continuity: maintaining believable spatial and temporal relationships within a scene. Preserving continuity involves maintaining proper screen direction, positioning and timing so that a series of shots showing pieces of an action fit together in a natural and seamless way.

Continuity editing: editing a sequence of shots to create a scene in which time and space seem to be uninterrupted; also called 'cutting for continuity.'

Contrast ratio: same as **lighting contrast ratio.**

Core: a plastic hub that **16mm** (and **35mm**) **camera original** film is wound on, usually in longer lengths (400 feet or more). Cores are also used to store film during **editing.**

Cross-lighting: a lighting arrangement in which two lights are positioned so that their beams cut across each other in an "X." Frequently, this type of set-up is used so that each light can do double duty, serving as a key light on one subject and a back light on another simultaneously.

Crystal sync: a method of synchronizing sound and image in double-system shooting. The camera's speed is controlled by a crystal oscillator while a crystal in the recorder generates a sync pulse.

CU: close-up.

Cut: point where a shot begins or ends; the point at which two shots are edited together.

Cutaway: a shot related to but not directly a part of the main action within a sequence. Cutaway shots can emphasize important details and also allow greater flexibility in editing.

D-A converter: a **digital-to-analog converter.**

Dailies: unedited footage; same as **rushes.**

DAT: see **Digital Audio Tape.**

DAW: see **digital audio workstation.**

Day-for-night: an often unconvincing technique of shooting night scenes in daylight

Daylight-balanced: 1) in the case of a light source, one which emits light of the "daylight" **color temperature** (5500°K). 2) in the case of a color film stock, one which is manufactured to reproduce color correctly when exposed under illumination of the "daylight" color temperature (5500°K).

Daylight-blue gel: same as **full-blue gel.**

Daylight spool: a black metal spool with solid sides that **16mm** (and sometimes **35mm**) **camera original** film is wound on for loading into a camera in low light.

dB: decibel.

Decibel: a measure of the **amplitude** of a sound.

Depth of field: the area in front of and behind the **plane of critical focus** in which objects appear to be in focus.

Diffusion: material used to scatter rays of light, thereby softening a light source. It is placed between the light source and the subject, often by attaching it to the **barndoors.**

Digital Audio Tape: (DAT); an audio recording format in which sound information is recorded onto **magnetic tape** as a series of number values.

Digital audio workstation: (DAW) a computer with advanced sound manipulation capabilities dedicated to manipulating and mixing digital audio.

Digital editing: the process of editing computer-readable files containing visual and audio material, using a computer.

Digital media files: computer-readable files containing visual and audio material.

Digital-to-analog converter: in a digital audio device or a computer, converts a series of numbers into sound or picture information; **D-A converter.**

Digitize: the process of converting film or video into **digital media files** that can be edited in a computerized editing system.

DIN: Deutsche Industrie Norm; European standard for rating film sensitivity. This scale is not interchangeable with **ASA, EI** or **ISO.**

Dissolve: an on-screen transition in which it appears as if one image gradually blends into another image; a **fade-out** simultaneously occurring with a **fade-in.**

Documentary film: a style of filmmaking which attempts to record some aspect of real life.

Dolly: 1) a wheeled support on which the camera rests. 2) the camera movement that results when a dolly is moved.

Double-perf film: a strip of film with **sprocket holes** along both edges.

Double-system sound: a type of filmmaking in which picture and sound are captured at the same time but on separate strands of material. They are also edited simultaneously but on separate strands (film and **magnetic fullcoat**).

Dusk-for-night: a technique of shooting night scenes during the brief dusk period after the sun has moved below the horizon but while there is still sufficient light from the sky.

Dutch angle: a shot composed so that the image is tilted in the frame.

Dynamic microphone: a microphone that does not use a power source to boost its signal.

Dynamic range: of a sound receiving device, the range from the softest sound it can register to the loudest it can handle; of a sound producing device, the range from the softest to loudest sound produced.

ECU: extreme close-up.

Edit decision list: (EDL) a list of **time code** numbers output from a computer which indicate each of the final editing choices, including the **in points** and **out points** of each shot, along with the type and duration of any transitions and effects.

Editing: process of cutting together various shots to create scenes or sequences.

EI: Exposure Index; a scale indicating film **speed**, or sensitivity, which is interchangeable with **ASA** or **ISO** for film stocks. EI 100 is the same as ASA 100 or ISO 100.

8mm: film **format** in which the strip of film is 8 millimeters wide.

18% gray: a shade of gray that reflects 18% of the light hitting it; the standard that light metering systems are based upon; same as **medium gray**.

Element: a precision-ground piece of glass in a lens.

ELS: extreme long shot.

Emulsion: a gelatin suspension of light sensitive **grains** of silver compounds spread on one side of the film's **base**.

Envelope: the glass covering of a **lamp** or light bulb.

Erase head: part of a recorder that produces a constant magnetic field which destroys any previously existing signal on a tape.

Establishing shot: a shot that shows the physical space, defining spatial relationships within the scene; usually a **long shot** or an **extreme long shot**.

Experimental film: a type of film that is often more concerned with the graphic or structural elements of film than it is with telling a story or documenting real life. Experimental film is a catch-all phrase that is frequently used to describe any abstract, non-narrative or other unusual approach.

Extreme close-up: a shot in which a small detail of a person or object fills the frame.

Extreme long shot: a shot that shows a large area of the physical environment.

Fade-in: an on-screen transition in which an image gradually appears out of a blank (usually black) screen.

Fade-out: an on-screen transition in which an image at full value gradually diminishes into a blank (usually black) screen.

Fall-off: the lessening in intensity of light falling on a subject as the subject moves farther from the light source.

Fast: 1) in a film stock, one with larger **grain** and, therefore, greater sensitivity to light. 2) in a lens, one with a large maximum **iris** opening.

Fast motion: accelerated action created by running the camera at a slower **frame rate** than the projection speed. It is also known as **undercranking**.

Feed reel: the reel on which film is stored before it is run through the camera or projector.

Fields: electronic horizontal lines that make up half of the information in a video frame. One video frame is comprised of two fields.

Filament: in a **lamp**, a small thread of tungsten that glows when heated, creating the lamp's light.

Fill light: light used to illuminate shadow areas and to control the **lighting contrast ratio.** The fill light is usually a **soft** light source.

Film chain: a device for transferrring film to video tape using a video camera and a film projector with a mirror set at a 45-degree angle between them.

Film plane: the plane in which the film travels as it runs through the camera gate where it is exposed; should coincide with the **focal plane.**

Filter: a piece of colored glass or gelatin that changes the characteristics of light passing through it.

Filter switch: on a super-8 camera, a switch that inserts or retracts (between the lens and the film) the orange **filter** that corrects daylight for shooting on **tungsten-balanced** film.

Fine cut: final stage in the editing process in which pacing and rhythm have been refined.

Fisheye lens: an extreme **wide-angle lens** that exagerates depth and causes horizontal lines to bend.

Focal length: the "size" of a lens, usually expressed in millimeters; the distance from the optical center of a lens to the focal plane.

Focal plane: the plane onto which the lens focuses rays of light; should coincide with the **film plane.**

Focusing ring: a ring on a lens that indicates (and focuses the lens for) the distance between the **focal plane** and the **plane of critical focus.**

Footcandle: a standard unit of light measurement. Footcandles can be measured with **incident light meters** but not with **reflected light meters.**

Format: the gauge or width of a film stock; 35mm, 16mm, 8mm, super-8, etc.

fps: frames per second.

Frame: 1) one single image on a strip of film. 2) the edges of the image as seen in the viewfinder or on the screen.

Frame rate: the speed at which the film runs through the camera, measured in frames per second (fps).

Frequency: a measure of how many cycles of a sound wave pass a certain point in a given time period. A large object vibrates slowly, producing a low-frequency sound, while a small object vibrates more quickly, producing a high-frequency sound.

Frequency range: the range from the lowest to the highest frequencies a sound producer can create or which a sound receiver can register.

f-stop: a number that indicates the diameter of the opening of the lens iris and therefore indicates the amount of light reaching the film.

Full-blue gel: a sheet of color-correcting acetate used to convert a tungsten-balanced movie light to the daylight **color temperature**.

Generation: a copy of a film, videotape, **magnetic tape** or **digital media file**.

Grain: photosensitive crystals of silver halides that are suspended in the gelatin of the **emulsion**.

Gray card: a rectangular piece of cardboard that is dyed a specific shade of gray on one side. A gray card reflects 18 percent of the light that hits it. It is neutral in tone, with no color bias.

Handheld: shooting film without using a tripod or other support. The cameraperson holds the camera.

Hard light: a quality of light characterized by distinct, well defined shadows.

Head: the beginning of a reel of film.

Head room: allowing appropriate compositional space above a subject's head.

Hertz: a unit used to measure a sound's **frequency**; also sometimes called cycles per second.

High angle shot: a shot taken with the camera at an angle above the subject.-

Highlight: the brightest area of an illuminated object.

Hypercardioid microphone: a microphone which picks up sounds coming from the front of the microphone more clearly than sounds coming from beside or behind it; same as **supercardioid microphone**.

Hz: see **Hertz**.

Incandescent lamp: a type of lamp that produces light by heating a tungsten filament. Household light bulbs are incandescent.

Incident light meter: a meter that measures the amount of light falling on the subject.

In focus: rendered sharp on film.

In point: in a computerized or video editing system, the beginning frame of the portion of the footage being cut.

Input: the process of converting pictures and sounds into **digital media files** that a computer system can store and manipulate.

Insert edit: in a computerized editing system, an edit that shifts existing material on the **timeline** so that new material does not cover old material.

Intensity: brightness of a light source.

Interface: in a computerized editing system, the on-screen configuration used to manipulate picture and audio material.

Intermittent movement: 1) the mechanism that moves the film through the camera or projector gate in a stop-and-start fashion so that each frame is stationary during the moment of exposure or projection; 2) the action of the pull-down claw.

Iris: an adjustable metal diaphragm inside a lens that can be opened or closed to control the amount of light reaching the film.

ISO: International Standards Organization; a widely used scale indicating film speed or sensitivity, which is interchangeable with **ASA** and **EI**. ISO 100 is the same as ASA 100 or EI 100.

Jump cut: a visually jarring edit that disrupts continuity.

Keycode: a machine-readable bar code form of **latent edge number** information.

Key light: the primary source of illumination in a lighting set-up.

kHz: see **kiloHertz**.

KiloHertz: (**kHz**); thousands of cycles per second; used to measure sound frequency or the **sample rate** of a digital device.

Kodalith: a brand of sheet negative commonly used in creating back lit titles.

Lamp: the bulb in a lighting unit.

Latent edge numbers: numbers printed along one edge of **16mm** and **35mm** film stock; used to match the edited **workprint** to the **camera original** during **conforming**.

Latent image: the invisible (or potential) image formed on film when it is initially exposed to light.

Latitude: the amount of overexposure and underexposure a film stock is capable of without losing detail. Latitude is greater in negative film than in reversal film.

Lavaliere microphone: a very small microphone that can be clipped to an actor's clothing or hidden on the set.

Leader: film, usually white, black or clear, that is spliced at the head and tail of a reel of film to protect the footage and allow for labeling. Leader can be used within the body of an edited film to create a black screen, clear screen, etc.

Leading the action: composing a moving object within the frame with more space in front of the object (in the direction it is moving) than behind it.

Lighting contrast ratio: the ratio of the intensity of the key light plus the fill light to the intensity of the fill light alone. It is written as a numerical ratio, for instance 2:1.

Log: the process of identifying specific footage or shots; organizing footge before editing.

Long lens: same as **telephoto lens**.

Long shot: in the case of a shot of a person, the whole person is shown from head to toe.

Loop: a small amount of slack in a strip of film between the constantly moving sprocket wheel and the intermittent movement in the camera or projector gate.

Low angle shot: a shot taken with the camera at an angle below the subject.

LS: long shot.

Macro lens: a lens capable of shooting extreme close-ups by focusing on very close objects. Usually a macro lens can focus as close as a few inches.

Magnetic fullcoat: thick magnetic tape sprocketed like film and available in the same gauges as film.

Magnetic tape: a flexible base, coated on one side with magnetically sensitive material, used for sound recording.

Master shot: a single shot of an entire action, usually taken with a wide field of view.

Matchback: the process of matching **camera original** footage to an edit made on a computerized editing system.

Match cut: a smooth edit that maintains the continuity of action from one shot to the next, creating the illusion of continuous motion.

MCU: medium close-up.

Medium close-up: a shot in which the size of the subject is between that of a **medium shot** and a **close-up**.

Medium gray: same as **18% gray**.

Medium long shot: a shot in which the size of the subject is between that of a **medium shot** and a **long shot**.

Medium shot: when of a person, usually from the waist up.

Microphone: a mechanical device that captures sound and converts it into a voltage signal.

MiniDisc: a digital audio format that records sound information onto a small disc.

MLS: medium long shot.

Montage: editing technique in which shots are cut together without concern for continuity. The juxtaposition of many shots creates new meaning that could not be conveyed in a single shot.

Motivated light: light with a source of origin that is shown or suggested within the scene.

MS: medium shot.

Narrative film: a style of filmmaking that tells a story.

Negative: a film stock that renders brightness and color values opposite to the way they appear in reality. What is white in reality is black on the film.

Neutral angle: a shot taken on the 180-degree line; a shot with neutral screen direction, favoring neither screen left nor screen right.

Neutral gray: same as **18% gray**.

Night-for-night: a technique of shooting outdoor night scenes at night while using lighting units to selectively illuminate and highlight.

NTSC: (National Television Systems Committee); the video standard used in North America.

Omnidirectional microphone: a microphone that picks up sounds equally well from all directions.

180-degree rule: rule governing the concept of screen direction. When a 180-degree line or axis is established within a scene, all shots must be taken from one side of the line in order to ensure proper screen direction.

180-degree shutter: a shutter with an opening that is a half circle of metal, or 180 degrees.

Open up: to open the lens iris.

Optical track: a soundtrack printed onto the edge of an answer print in which sound is rendered as a pattern of dark lines on clear film. As light is shone through the optical track this pattern will dictate the voltage pattern sent to the speaker.

Orange 85 gel: a sheet of color correcting acetate used to convert daylight to the tungsten color temperature.

Out of focus: the image is not sharp on the film.

Out point: in a computerized or video editing system, the ending frame of the portion of the footage being cut.

Output: the process of retrieving images, sounds or other information from a computerized editing or mixing system.

Outtakes: shots that are not selected for inclusion in the edited film.

Overexpose: to allow too much light to hit the film.

Overlapping action: a shooting technique in which an action is repeated while being shot multiple times from a variety of camera angles; used to create **match cuts**.

Overwrite edit: in a computerized editing system, an edit that covers existing material on the selected portion of the **timeline** with new material.

Oxide: magnetically sensitive material used in audio tape and magnetic fullcoat.

Pan: a camera movement in which the camera is pivoted along its horizontal axis.

Parallel editing: editing back and forth between two scenes to indicate that they are occurring simultaneously.

Perforations: same as **sprocket holes**.

Persistence of vision: a physiological phenomenon; when a series of drawings or photographs of an object in motion are viewed in rapid succession, each image is briefly retained by the retina and the brain blends the individual pictures together, creating the illusion of motion.

Pick-up pattern: a microphone's directional characteristics for gathering sound.

Plane of critical focus: the plane in which all objects are in sharpest focus. It is parallel to the **focal plane** and its distance from the focal plane is determined by the distance set on the **focusing ring**.

Playback head: the part of a recorder that reads the signal stored on a tape.

Positive print: a copy of a negative image in which brightness and color values are the opposite of those in the negative. In a positive print values are the same as what was seen through the viewfinder during original photography.

Post-dubbed sound: sound that is recorded after the film has been shot, which is added to a film in post-production

Post-production: the editing and finishing stages of the filmmaking process.

Pre-production: the planning and organizing process before the actual shooting of a film begins.

Pressure plate: a spring-loaded plate behind the film that holds the film flat against the **aperture plate** in the camera. In super-8 the pressure plate is part of the plastic film cartridge.

Prime lens: a lens with a single, fixed focal length.

Processing: running exposed film through chemicals that develop and fix the **latent image**, making it a visible, permanent image.

Production: stage in the filmmaking process during which the film is shot.

Production value: the overall look of a film, or those elements that affect the look of the film such as locations, lighting, sets, props, acting, etc.

Proposal: written statement of a film's concept; usually the first step in the scripting process.

Pulldown: a film-to-videotape transfer method that compensates for the difference between film and video frame rates.

Pull-down claw: the pin or claw that engages a perforation of the film and advances it one frame, while the shutter blocks light from the moving film.

Pull focus: changing focus during a shot in order to keep a moving object in focus.

Quality: of a light source; a primary characteristic of light, broadly defined as being either **hard** or **soft**.

Quartz-halogen lamp: a tungsten lamp with a glass envelope made of quartz glass; quartz-halogen lamps create more light intensity for their size than standard incandescent lamps.

Rack focus: shifting focus during a shot in order to direct attention from one area of the frame to another.

Recorder: a device that records an audio signal onto magnetic tape so that it can be played back later.

Record head: the part of a recorder that encodes the audio signal onto the magnetic tape.

Reflected light meter: a meter that measures the amount of light reflected by a subject; the type of light meter built into all super-8 cameras.

Reflector: the scoop-shaped part of a lighting unit that directs the beam of light in one general direction.

Registration pin: a pin that engages a **sprocket hole** during exposure, holding the film perfectly still.

Release print: projection print of a film made from the **camera original** and incorporating all **timing** changes approved in the **answer print**.

Reversal: a film stock that renders brightness and color values as they appear in reality. What is white in reality is white on the film.

Rough cut: intermediate editing stage in which shots are edited and re-edited until the footage is refined into a fine cut.

Rule of Thirds: a compositional guideline in which the frame is divided into thirds horizontally and vertically with important objects positioned at the intersection of the dividing lines.

Running time: the length of time a film lasts on the screen.

Rushes: unedited footage; same as **dailies**.

Sample rate: the number of times readings are taken by a digital audio device; measured in **kiloHertz**.

Sampling: in digital audio recording, the process of taking many readings of the sound information and assigning number values to this information.

Scene: a film is divided into a series of scenes, each usually consisting of an event that takes place during a continuous period of time in a single location.

Screen direction: the direction a character or object is facing or the direction of movement within a shot. Screen direction is usually described as being screen left, screen right or neutral.

Screen left/screen right: an indication of screen direction or position. A character positioned on the left side of the frame, as seen through the camera and on the screen, is said to be screen left. That same character, if facing the other side of the frame, would be said to be facing screen right.

Screenplay: same as **script**.

Script: written scenes for a film describing relevant action and dialogue, usually following a specific format.

Script breakdown: an organized listing of the various details within a script, such as actors, locations and props; used to gather and organize the necessary elements for a shoot.

Shadow: the darker area of an illuminated object or frame.

Sheet negative: a large format high-contrast negative often used in creating back-lit titles.

Shooting plan: a list grouping similar shots together so that all the shots with the same camera position and lighting set-up are shot at once, allowing for economical use of shooting time.

Shooting script: chronological list describing each shot within a scene or an entire film in terms of image size, camera angle and camera movement.

Short lens: same as **wide-angle lens**.

Shot: a length of film unbroken by a cut or by shutting the camera off; a continuous series of frames.

Shotgun microphone: a microphone with a narrowly directional pick-up pattern, which picks up sounds coming from the front of the microphone more clearly than sound coming from beside or behind it.

Shutter: a metal disk that spins in front of the camera aperture. Part of the disk is cut away so that when the film is in motion the metal prevents light from reaching the film. When the film is motionless the cut-out portion of the disk allows light to expose a frame.

Shutter angle: the size, measured in degrees, of the camera's **shutter opening**.

Shutter opening: the cut-out portion of the shutter which allows light to expose a frame. The angle (in degrees) of the shutter opening and the **frame rate** of the camera determine the **shutter speed**.

Shutter speed: the amount of time that light hits each frame of film.

Single-perf film: a strip of film with **sprocket holes** along only one edge.

Single-system sound: a method of shooting sync sound in which picture and sound are captured on the same strip of material at the same time.

16mm: film **format** in which the strip of film is 16 millimeters wide.

Slow: 1) in a film stock one with smaller **grain** and therefore, less sensitivity to light. 2) in a lens, one with a relatively small maximum **iris** opening.

Slow motion: slowed down action on the screen that results from shooting at a higher frame rate than the speed of projection.

SMPTE time code: a series of numbers developed by the Society of Motion Picture and Television Engineers that identifies individual video frames and allows videotape and computerized editing to be frame-exact.

Socket: the part of a lighting unit that holds the lamp.

Soft light: a quality of light that is characterized by diffused lighting and indistinct shadows.

Sound effects: sounds on a film soundtrack (such as footsteps, traffic noise, a doorbell, etc.) which are not music or speech.

Sound mix: the process of recording edited tracks together onto a single, uncut track. The level and character of each individual sound can be controlled to create a multi-layered **soundtrack**.

Soundtrack: the aural accompaniment to a film.

Speed: a measure of the film's sensitivity to light in **ASA, ISO** or **EI;** a **fast** film is more sensitive (and requires less light) than a **slow** film.

Splice: the cut or edit where two pieces of film are physically joined together.

Splicer: device used to cut and tape film during editing.

Sprocket: a gear inside a camera that engages **sprocket holes** on the film to move it through the camera.

Sprocket holes: a uniform row of holes along one or both edges of the film, engaged by the **sprocket wheel** and the **pull-down claw** in order to advance the film through the camera or projector.

Sprocket wheel: the toothed wheel that drives the film through the camera or projector by engaging the film's perforations.

Static shot: a shot in which the camera does not move.

Stop: 1) each of the **f-stop** numbers. 2) the difference between one f-stop and the next.

Stop down: to close the lens **iris**.

Storyboard: a drawn version of a script or treatment resembling a comic book; used to pre-visualize a scene or a film.

Super-8: a film **format** in which the strip of film is eight millimeters wide but with a larger frame area than 8mm film.

Super-16: 16mm film shot with a modified camera (using **single-perf film**) to create a frame area with a 1.66:1 **aspect ratio**.

Supercardioid microphone: see **hypercardioid microphone**.

Sync head: a special head in a recorder that records a sync pulse on the tape.

Sync pulse: a reference signal recorded onto the magnetic tape and used for synchronization in double-system shooting.

Sync sound: double-system sound that is matched exactly to picture during shooting.

Tail: the end of a reel of film. Film that has not been rewound is "tails out."

Take: one individual version of a shot. Often there are several takes of each shot.

Take-up reel: the reel on which the film is stored after running through the camera or projector.

Tape recorder: a device that records an audio signal onto magnetic tape so that it can be played back later.

Telecine: a sophisticated device used to electronically transfer film to videotape.

Telephoto lens: a lens with a long focal length which will capture only a narrow angle of the view in front of it; the more telephoto a lens is, the greater its magnifying power.

35mm: film **format** in which the strip of film is 35 millimeters wide.

3:2 pulldown: a specific type of **pulldown** in which 24 film frames are converted to 30 video frames by copying selected film frames to multiple video fields. Using 3:2 pulldown, the film is also slowed down by 0.1% during transfer, resulting in video that runs at 29.97fps.

Tilt: a camera move in which the camera pivots up or down along its vertical axis.

Time lapse: a type of cinematography in which single frames are taken at regular timed intervals, resulting in extremely fast motion.

Timeline: in a computerized editing system, an on-screen representation of visual and audio material as it is being edited.

Timing: adjustments made to the color and exposure of individual shots when a film is printed.

Tracking shot: a dolly shot in which the camera moves with a moving subject, keeping it in frame.

Treatment: a written description of a film's concept and structure; in a narrative film the treatment would be a scene-by-scene description of the plot.

Treble: high-frequency sound.

Trims: frames cut off of the head and tail of shots that are edited into the film.

Tripod: a three-legged support on which the camera rests.

Tungsten-balanced: 1) in the case of a light source, one which emits light of the tungsten **color temperature** (3200°K). 2) in the case of a color film stock, one which is manufactured to reproduce color correctly when exposed under illumination of the tungsten **color temperature** (3200°K).

Undercranking: shooting at a frame rate slower than that at which the film is later projected, resulting in fast motion on the screen.

Underexpose: to allow too little light to hit the film.

Unmotivated light: light which does not have a logical source shown or suggested in a scene.

Video dailies: a low-quality film-to-video transfer containing special information used for computerized editing of a film.

Viewer: an editing device consisting of a gate, screen, feed reel and take-up reel, that allows the filmmaker to look at footage and select and edit shots.

Voice-over: speech that is heard on a soundtrack while the speaker or narrator is not seen.

Wavelength: the length of one cycle of a sound wave.

Wide-angle lens: a lens of short **focal length** which will capture a wide angle of the view in front of it.

Workprint: a frame-for-frame copy of a camera original film used for editing.

Zoom lens: a lens with a continuously variable range of focal lengths, usually ranging from a **wide-angle** position to a **telephoto** position; a lens that is capable of a "zoom" effect.

Index

Allen, Woody, 58

American Movie, 14

Amplitude, 142, 147, 151

Analog-to-digital converter (A-D converter), 153

Animation, 13-15

 frame rate. 21

Answer print, 93, 107

Aperture, lens, 26-27

Aperture plate, 25

ASA (American Standards Association), 46

Aspect ratio, 12

Assembly, 90

Audio tracks, 102, 105, 107

Avid Film Composer, 101

Back light, 128

Background light, 129

Barndoors, 123-124

Belfast Maine, 14

Bertolucci, Bernardo, 59

Bin, 103

Bit rate, 151

Black-and-white film, 46, 49-51

 and color temperature, 133

 and super-8 filter switch, 49

Blair Witch Project, The, 62

Blocking, 64

Boom, 145

Borthwick, Dave, 15

Bounce card, 123

Brakhage, Stan, 15

Breaking the Waves, 62

Buffalo 66, 45

Burns, Ken, 14

Cable sync, 149

Camera

 handheld, use of, 61-62

 and intermittent movement, 26

 lens, 21-25

 mechanics of, 16-19

 pin-hole, 21

Camera angle, 54-56

 and match cuts, 84-85, 87

Camera gate, 26

Camera movement, 61-64

 across 180-degree line, 71-75

 to manipulate perception of space on screen, 69

Camera speed, 19

Camera take, 52

Celluloid film, 10

Cellulose triacetate, 42

Changing bag, 19

Changing tent, 19

Chicken Run, 15

Cinema verite, 14

Cinematic illusion, role in continuity, 87

Cineon format, 98

Citizen Kane, 109
Civil War, 14
Clips, 103
Close-up shot, 52-54
Color film, 46-48
 daylight-balanced, 48, 131-133
 and light, 46-47
 Tungsten-balanced, 48, 131-133
Color quality, 132
Color temperature, 132-133
Color, as a dominant element of
 composition, 58
Composition
 and balance within frame, 67
 camera angles in, 54-56
 in creating illusion of three-
 dimensional space on screen, 56
 guidelines for, 57-59
 image size in, 52-54
 outside the frame, 60
 rule of thirds in, 57-58
Compositional dominance, 58-59
Compression, 102
Conforming, 92-93
Conformist, The, 59
Continuity
 alternatives to, 88-90
 and editing, 84-85
 and match cuts, 84
 and screen direction, 71-79
 and size of subjects, 79-80
 and space, 69-70
 and time, 69-70
Continuity editing, 84-87
Contrast, as a dominant element in
 composition, 59
Coppola, Francis, 88
Cross-lighting, 129
Crystal sync, 149

Cutting,
 in digital editing, 103
 on action, and match cuts, 86
Cutway
 use of in match cuts, 77-78
 use of to change screen direction, 77
Dailies, 90
Day-for-night shooting, 136-138
Daylight-balanced film, 48
Decibels, 142
Depth of field, 32-35
 one-third two-thirds rule, 34
 tables, 35-41
Deren, Maya, 15
Diffusion, 123
Digital audio recording, 151
Digital audio workstation (DAW), 54
Digital editing, 98
Digital media files, 98
Digital sound editing, 153-155
Digital-to-analog converter (D-A
 converter), 153
Digitize, 99
DIN (Deutsche Industrie Norm), 46
Dinosaur, 15
Documentary film style, 13-14
 treatment for, 108,114
Dog Star Man, 15
Dolly, 62
 dolly in v. zoom in, 63-64
Dominant element,
 in composition, 59
Don't Look Now, 89
Do the Right Thing, 56
Double-system sound, 149
Dusk-for-night shooting, 137,138
Dutch angle shot, 56

Eastman Kodak, 11, 45
 16mm film stocks, 50
 super-8 film stocks, 51
 introduction of super-8 film, 11
Eastman, George, 10
Edit Decision List (EDL), 107, 154
Editing
 and continuity, 84-87
 insert, 105
 long-take style of, 89-90
 mechanics of, 90-93
 montage, 89
 parallel, 88
 overwrite, 104-105
 and rhythm, 83
 splicer, 90
 viewer, 90
Egoyan, Atom, 129
EI (Exposure Index), 46
 rating for black-and-white and
 color films, 49
18% gray, 27-29
 card, 29-30
Ektachrome
 16mm film stock, 50
 super-8 film stock, 51
Empire, 90
Emulsion, 42-44
Establishing shot, 87
Exotica, 129
Experimental film style, 15
 treatment for, 108,114
Exposure
 and amount of light, 26
 and effect of shutter angle, 25
 and effect of shutter speed, 25
 and incident light meters, 28-30
 and latitude, 47
 and reflected light meters, 28-30

Fast motion, 20
Feed reel
 in camera, 16
 start of film path, 18
Ferrous oxide, 146
Fields, video, 99
Figgis, Mike, 90
Fill light, 128
Film
 16mm, 10, 45, 50
 black-and-white, 46
 cleaning after editing, 94-95
 color, 46
 negative, 42-43
 reversal, 44-45
 sensitivity, 46-47
 storage, 95
 super-8, 11, 45, 51
 transferring to tape, 95-97, 107
Film plane
 and measuring focus, 32
Film speed, 25
Film styles, 13-15
Film-to-video transfer, 99
Filters
 daylight blue gel, 48, 49, 131
 full blue gel, 131
 orange 85 gel, 48, 49, 131
 switch, 48
Fine cut, 91
Fisheye lens, 22
Fixed focal length lens, 22
Flaherty, Robert, 14
Fluorescent light, filters and, 48-49
Focal length
 and depth of field, 32
 and depth of field tables, 35
 and prime lenses, 22
 and zoom lens, 24, 35

Focal plane, 32
Focus, 32-35
 pulling, 34
 rack, 66
Focusing distance
 and depth of field, 32-35
 and depth of field tables, 35-41
Focusing ring, 32
Footcandles, 121
Ford, John, 13
Formats, film See also 8mm, 16mm,
 35mm, super-8, 10-12
Fps, 19
 and controlling film exposure, 25
Frame, 52
 composition outside of, 60
Frame rate, 19
 and animation, 21
 and fast motion, 20
 and relationship between camera
 and projector, 19-20
 and relationship to shutter speed, 25
 and slow motion, 20
 and time lapse, 20
Frequency, 143
Friedrich, Su, 15
f-stop, 26-27
 as a light meter reading, 27-31
 and depth of field, 32
 and depth of field tables, 35-41
 and incident light meters, 29
 and lighting contrast ratios, 134
Full blue gel, 131
Generation, 151
Godfather, The, 89
Graduate, The, 88
Graphics, 106
Gray card, 28-31, 51, 134

Hard light, 122
 and three-point lighting, 128
Head, film, 91
Hertz (Hz), 143
Herzog, Werner, 14
High angle shot, 54
Hitchcock, Alfred, 59, 89
Image size
 and match cuts, 85
 in relation to shots, 52-54
 on storyboard, 112-113
In points, in digital editing, 104, 107
Incandescent lamps, 124-125
Incident light meter, 27,30, 122, 134
Input, 98
Insert edit, 104
Interface, 103
Interiors, 58
Intermittent drive, 26
Intermittent movement, 16-17
Invasion of The Body Snatchers, 83
Iris, lens, 25
 and controlling the amount of
 light hitting film, 26
 automatic, in super-8
 camera, 27,29
 opening, 26
ISO (International Standards
 Organization), 46
Jarmusch, Jim, 15
Jump cut, 84-85
Key light, 127
Keycode, 101, 107
Kilohertz (kHz), 151
Kodachrome, 50-51
Kodalith, 138
Koyaanisqatsi, 15
Last Year at Marienbad, 13
Latent edge numbers, 92, 101, 107

Latent image, 42
Leader, 91
Leading the action, 65
Lee, Spike, 56
Lens, camera, 21-25
 composition, 22-23
Light,
 and color, 130-133
 and color film, 47, 130
 controlling amount hitting film, 25
 daylight, 48
 filters, 48-49
 measurement, 121-122
 metering, 27-31, 121-122
 motivated, 129-130
 quality of, 122-123
 tungsten, 48-49, 130-131
Light meters, 27-31
 incident, 30-31
 reflected, 27-30
 super-8 built in, 27
Lighting
 angles, 126-129
 and contrast, 133-136
 and night-shooting, 136-138
 three-point, 127-129
 tools, 123-124
 types of, 47-49
Lighting diagram, 118-119
Little Dieter Needs to Fly, 14
Logging, 101
Long shot, 52
Long take, style of
 filmmaking, 89-90
Low angle shot, 54
Lumiere brothers, 10
Macro lens, 24-25
Magnetic fullcoat, 149
Magnetic tape, 146

Master shot, 81
Match cuts, 84
 and overlapping action, 85
 techniques, 85-87
Matchback, 101, 107
Matrix, The, 98
Medium gray standard, 27-28, 30
Medium shot, 52-54
Meshes of the Afternoon, 15
Microphones, 143-146
 cardioid, 145
 condenser, 144
 dynamic, 144
 hypercardiod, 145
 lavaliere, 145
 omni-directional, 144
 pickup pattern, 144-146
 shotgun, 145
 supercardioid, 145
MiniDisk, 152
Montage editing, 89
Morris, Errol, 14
Motion picture camera
 diagram, 18
 and relationship between frame
 rate and shutter speed, 25
Motivated light, 129-130
Movement
 across the 180-degree line, 73
 as a dominant element in
 composition, 59
 and manipulating way in which
 space is perceived on screen, 64-65
 in the shot, 64-65
 of the camera, 59-63
Muybridge, Edward, 9
Nanook of the North, 14
Narrative film style, 13-14
 treatment for, 109

Negative film
 16mm film stocks, 50
 exposure of, 43
 and latitude, 47
 and positive print, 43
 workprint, 45
Neutral angle shot, 77-79
Neutral gray, 27
Nichols, Mike, 88
Night Mail, 14
Night-for-night shooting, 136
NTSC (National Television
 Systems Committee), 99
180-degree rule, 71-75
 and camera movement across axis, 79
One-third two-thirds rule, 34
Optical effects, 106
Optical printer, 106
Optical sound reader, 155
Optical track, 155
Orange 85 gel, 131
Out points, in digital
 editing, 104, 107
Output, 98, 107
Outtakes, 90-91
Overexposure, 28
 and latitude, 47
Overwrite edit, 104
Pan, 61
Parallel editing, 88
Persistence of vision, 9
Pi, 45
Pin-hole camera, 21
Pinocchio, 15
Plane of critical focus, 32
Positive print, 43

Pre-production
 and production value, 116
 and scheduling, 116
 script, 109
 shooting script, 111
 storyboard, 111
 treatments, 108-109, 114
Pressure plate, 16-17
Prime lens, and fixed
 focal length, 22
Printing to tape, 107
Projected motion, 19-20
Psycho, 89
Pulldown, 99-100
Pull-down claw, 17
Quartz halogen lamps, 125
Rack focus, 66
Recorders, 146-148
 DAT, 152
Reflected light meter, 27-29
Reflector, light, 123
Reggio, Godfrey, 15
Registration pin, 17
Reiner, Rob, 69
Reversal film, 42, 44, 50-51
 16mm film stocks
 and 16mm processing, 45
 exposure of, 44
 and latitude, 47
 and super-8, 45
Roeg, Nicholas, 89
Rough cut, 91
Rule of thirds, 57
Run Lola Run, 90
Running time, 69
Russell, David O., 65
Sample rate, 151
Sampling, 151
Scenes, 52

Screen direction, 71-79
 and changing direction within
 a scene, 75-79
Screenplay, 109
Script, 109
 breakdown, 116
*Secret Adventures of Tom
 Thumb, The*, 15
Sheet negative, 138
Shooting plan, 117
Shooting script, 111
Shot
 and image size, 52-54
 camera angle in, 54-55
 choice of in manipulating way
 space is perceived on screen, 69
 close-up, 52-54
 Dutch angle, 56
 high angle, 54
 lengthening, 105
 long shot, 52
 low-angle, 54
 medium, 52-54
 movement in, 64-65
 relationship to film's continuity, 70
 shortening, 105
 tracking, 64
 transitional, use of to change
 screen direction, 79
Shutter angle, 25
Shutter opening, 18
Shutter speed, 25
Siegel, Don, 83
Sine wave, 142
Single-system sound, 148
Sink or Swim, 15

16mm format
 and exposure latitude in
 day-for-night shooting, 137-138
 and fixed focal length lenses, 24
 and filters, 48, 133
 Eastman Kodak film stock, 50
 film, loading in camera, 18
Slow motion, 19
Smith, Chris, 14
SMPTE time code, 101, 107, 154
Society of Motion Picture and
 Television Engineers (SMPTE), 101
Soft light, and three-point
 lighting, 128
Sound
 characteristics of, 142
 decibels (dB), 142
 dynamic range, 142
 frequency, 143
 wavelength, 142
 editing on film, 151-152
Sound speed, 19
Soundtrack, 141
Space, creating illusion
 of on screen, 69-70
Spacial illusion, use of to heighten
 suspense in film, 70-71
Splicer, 90
Splicing, 103
Sproket holes, 16
Stagecoach, 13
Stand By Me, 69
Static shot, 61
Storyboard, 111-114
Stranger Than Paradise, 15
Super-8
 post-dubbing, 150
 and single-system sound, 148

Super-8 cameras
 camera speed, 19
 built-in filter switch, 48
Super-8 film
 Eastman Kodak film stocks, 51
 loading in camera, 19
Suspicion, 59
Sync pulse, 149
Tail, film, 91
Telephoto lens, 22
 in handheld shots, 62
Thin Blue Line, The, 14
35mm format
 and exposure latitude in day-for-night shooting, 137-138
 and fixed focal length lenses, 24
Three Kings, 65
Three-point lighting, 127-129
3:2 pulldown, 100
Tilt, 61
Time
 compressing of in filmmaking, 69
 illusion of on screen, 69-70
 expansion of in filmmaking, 69
Timecode, 90
Time lapse, 20
Timeline, 103-107
Titanic, 98
Titles, 138-140
Touch of Evil, 127
Toy Story, 15
Tracking shot, 64
Transitional shot, 79
Transitions, 93-94, 106, 107
Treatment, film, 108
Trims, 91
Tripod, 61
Tungsten-balanced film, 48
Undercranking, 20

Underexposure
 and latitude, 47
Video, 99
Video dailies, 99,101
Video frame, 101
Video transfer, 95-97
Vinyl, 90
Visual effects, 106
 fade, 106
 dissolve, 106
Von Trier, Lars, 62
Warhol, Andy, 90
Wavelength, 142
Welles, Orson, 127
Wide-angle lens, 22, 32-33
 in handheld shots, 62
Wiseman, Frank, 14
Workprint, 45, 90-92, 99
Zoom lens, 24
 focusing, 34
Zoom shot, 24

About The Authors

The authors of *Shot by Shot: A Practical Guide to Filmmaking*, John Cantine, Susan Howard, and Brady Lewis, are all active independent filmmakers with a combined 45 years of experience teaching filmmaking. They are all members of the faculty of Pittsburgh Filmmakers' School of Film, Video, and Photography. **John Cantine** received his M.F.A. in Film Production from Ohio University. **Susan Howard**'s B.A. is in Film Production from Penn State University, and she has worked on projects as diverse as the low-budget splatter feature *Street Trash* and, in recent seasons, as the editor of *Mr. Rogers' Neighborhood*. **Brady Lewis**, Pittsburgh Filmmakers' Director of Education, has a B.F.A. from New York University. His experimental work has been recognized by many regional and national film production grants, screenings and festival awards. His feature-length film *Daddy Cool* will be released in 2001.

About Pittsburgh Filmmakers

Pittsburgh Filmmakers, one of the oldest and largest media centers in the United States, has provided support and equipment access to artists working in film, video, photography and digital media since 1971. Serving as the most prominent exhibitor of American independent films and foreign films in western Pennsylvania, Filmmakers operates four theaters and annually hosts the two-week Three Rivers Film Festival. Pittsburgh Filmmakers' School of Film, Video and Photography is an accredited institutional member of the National Association of Schools of Art and Design (NASAD), offering a comprehensive curriculum encompassing film production, film history and theory, video production, photography and digital media.

For more information on Pittsburgh Filmmakers and its programs or on *Shot by Shot: A Practical Guide to Filmmaking*, visit us on the web at **www.pghfilmmakers.org** or at **www.shotbyshotonline.com** or call us on the telephone at (412) 681-5449.